D1495068

The Hampshire Collection

HФH

HAMPSHIRE COUNTY LIBRARY

WITHDRAWN

Class number: H942·2425

Title number: 9781848686724

C014609208

Hampshire
County Council

CL82 7/02 10k

AMBERLEY PUBLISHING

HAMPSHIRE COUNTY	
LIBRARIES	
C 014609208	
Macaulay	07/04/10
H942.2725	£ 13.99
9781848686724	

First published 2009

Amberley Publishing Plc
Cirencester Road, Chalford,
Stroud, Gloucestershire, GL6 8PE

www.amberley-books.com

Copyright © Jo Gosney, 2009

The right of Jo Gosney to be identified as the
Author of this work has been asserted in accordance
with the Copyrights, Designs and Patents Act 1988.

ISBN 978 1 84868 672 4

All rights reserved. No part of this book may be
reprinted or reproduced or utilised in any form
or by any electronic, mechanical or other means,
now known or hereafter invented, including
photocopying and recording, or in any information
storage or retrieval system, without the permission
in writing from the Publishers.

British Library Cataloguing in Publication Data.
A catalogue record for this book is available from
the British Library.

Typeset in 9.5pt on 12pt Celeste.
Typesetting by Amberley Publishing.
Printed in the UK.

Introduction

Apart from being mentioned in the Domesday Book as *Ferneberga* (hill of ferns), the earliest notable reference to Farnborough was when John Mackey wrote *A Journey Through England* in 1722. He observes that between Egham in the North and Farnham in the South, 'there was not a house to be seen except the hunting seat of the Earl of Anglesey's called Farnborough, which makes the better appearance standing in so coarse a country and being very well planted with trees'.

He actually missed the village, as it was hidden behind a hill, but it was still to be some years before any material changes happened. Nevertheless, the speed with which Farnborough grew from a population of 477 in 1851, to nearly 60,000 has been phenomenal. Unlike many places, there was no sudden industrial growth in the nineteenth century, but the arrival of the army in neighbouring Aldershot did have a major impact. First North Camp was constructed in the 1850s at the southern end of the parish, encouraging workers to leave the land to work in the burgeoning commercial area serving the needs of the military.

The next major influence was the opening of the balloon factory in 1905, later to become the Royal Aircraft Establishment and a major employer for the next seventy years. The First World War saw an influx of over 5,000 workers to the RAE necessitating the rapid building of new houses in the Rafborough and Pinehurst Estates.

In the 1930s Cove and part of Hawley were amalgamated with Farnborough Urban District Council, which again increased the overall population. The 1950s and '60s saw new housing estates at Hawley and Cove, and in the 1970s the opening of the M3 made Farnborough a popular commuter town. However, all that rapid expansion was

achieved at the expense of many of our historic buildings. Almost every farmhouse and most of our large Victorian buildings have gone. Fortunately, there are still a few pockets within conservation areas where we can look back at the landscape as seen in former years.

Farnborough is again undergoing a great period of change and the mind quickly adjusts to new vistas.

One of the greatest changes has been on the site of the Royal Aircraft Establishment, formerly owned by the Ministry of Defence. The airport is now owned by TAG Aviation and has become a leading international business airport. The former RAE buildings are owned by SEGRO, who have invested millions in creating the new IQ Business Park. New hotels have also been built to cater for the increased business clientele.

At long last, the redevelopment of the town centre built only fifty years ago is under way. What happened to the state-of-the-art shopping centre which won architectural accolades in the 1960s? Shopping habits have changed and today the emphasis is on the mixed residential and retail units that are now being built. Will the stunning new glass buildings stand the test of time? One such building, Concept 2000, was completed in 1986 and within twenty years was demolished to make way for housing, because it was not suitable for conversion.

Since my first foray into the world of writing about local history fifteen years ago, it has often been suggested that people would like to see a publication that compares the past with the present. The invitation to write this book gave me that opportunity but the challenge has not been without difficulties. Extensive building, unending roadworks and an unpredictable summer have all been obstacles in recording the present street scene and often it was impossible to make a direct comparison. One gratifying aspect of this venture has been to realise that despite the increased urbanisation there are still areas which are well covered with trees.

In laying out the book, I have endeavoured to illustrate the evolution of the town by leading the reader through from north to south, with a few diversions along the way. Hopefully this has given an overall picture of *Farnborough Through Time*.

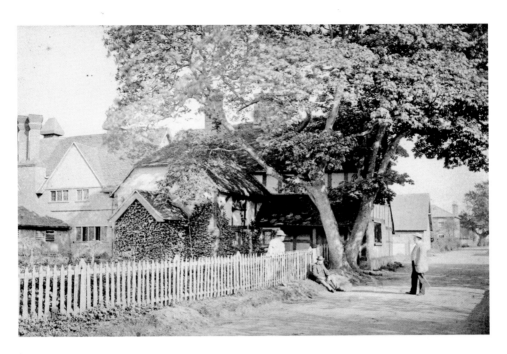

Homestead Farm in Ship Lane

A century ago, the farm was the working hub of the Farnborough Hill Estate. After the Empress Eugénie, widow of the exiled Emperor Napoleon III of France, purchased the estate in 1880 many of the buildings were adorned with Napoleonic symbols such as those on the hopper head shown as an inset. Home Farm Close, on the right, was the site of the main farmyard.

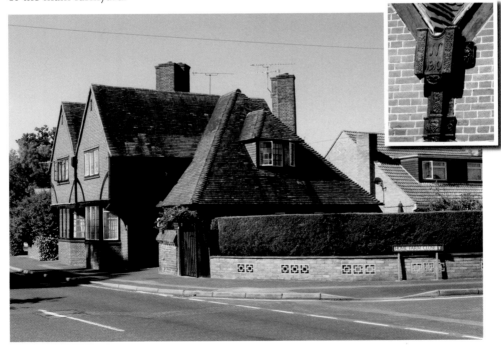

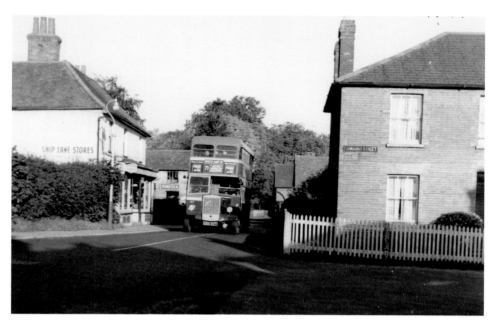

The Corner of Farnborough Street and Ship Lane, 1958

This ancient lane was used by the sheep and cattle drovers taking their animals through from Blackwater Fair to Guildford, crossing the River Blackwater on the eastern edge of the village. Ship Lane Stores, which was formerly an eighteenth-century public house called the Rose & Crown, has been replaced by modern houses.

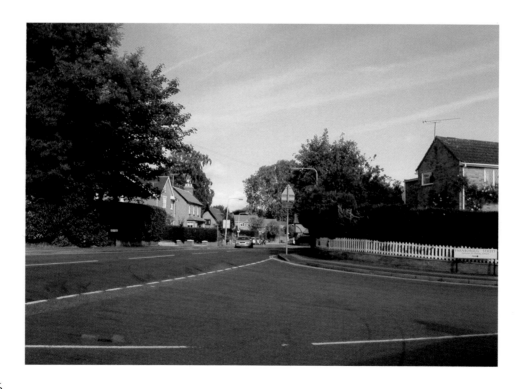

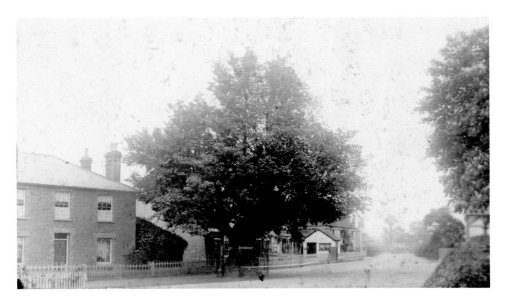

The Centre of the Village, *c.* 1897

Outrage was expressed when this ancient elm tree was cut down in 1917 as it featured in early parish records and had been the focal point for many village activities. The small white cottage has gone and the three cottages behind the tree are now visible. On the right is the old seventeenth-century farmhouse, now divided into four cottages. Despite being devoid of shops and only having two pubs, the old village still exudes an air of antiquity within a very urbanised town.

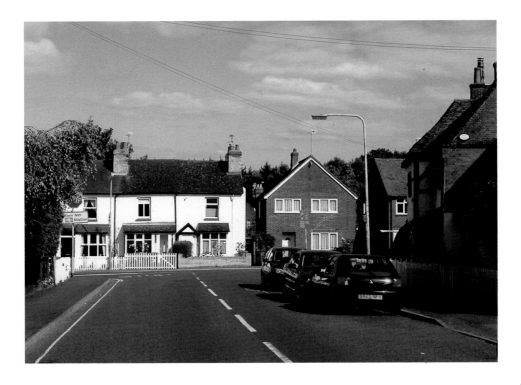

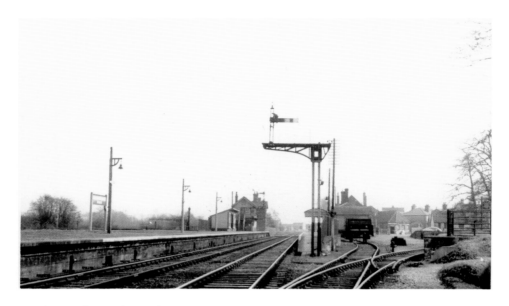

Farnborough North Station

The Reading to Guildford line on the South Eastern Railway opened in 1859 and connected Liverpool to the south coast without having to go via London. It transported large numbers of troops for the new army camp at nearby Aldershot, as well as hundreds of horses brought in from Ireland for military use. The marshalling yards were behind the platform on the left. Since the above photograph was taken in 1956, use of the station has diminished and it has become almost rural.

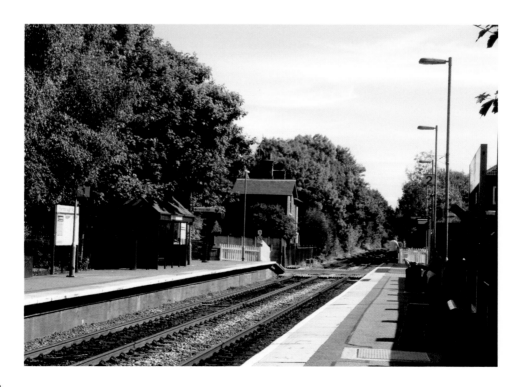

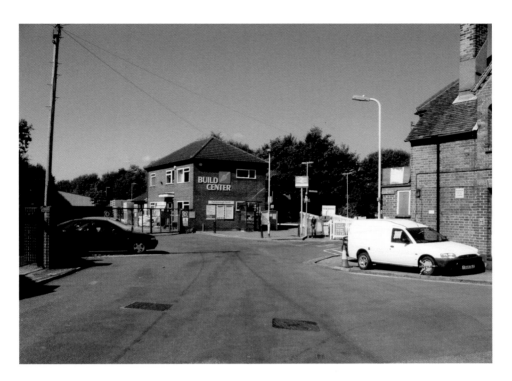

A Station Transformed

A builders' yard has now replaced the buildings seen below at Farnborough North Station in the 1960s. On the right are the remains of the old Simond's Brewery buildings, constructed in the 1860s to cater for the military trade. The beer was brought by rail straight from the Reading brewery and unloaded directly into the bottling plant where a number of the villagers were employed.

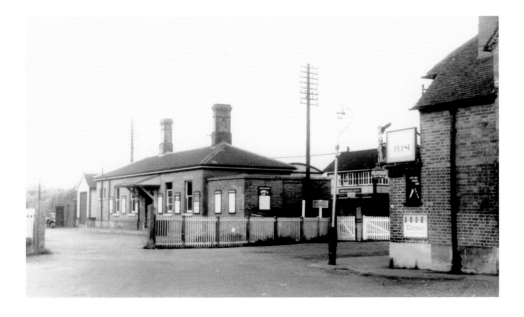

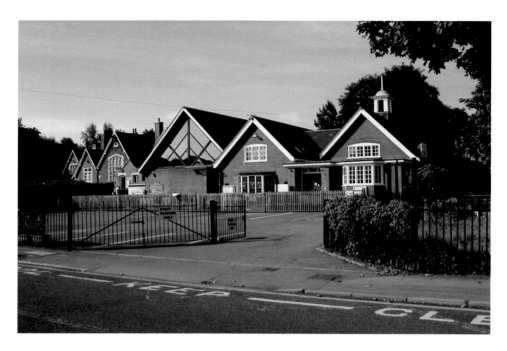

North Farnborough Infant School

A new infant school, seen below, was built on Rectory Road, near Farnborough Street, in 1905. It was next door to the National School which was built in 1858 on land given by Thomas Longman, the publisher and owner of Farnborough Hill. All the buildings are now occupied by North Farnborough Infant School, and a new hall has been added.

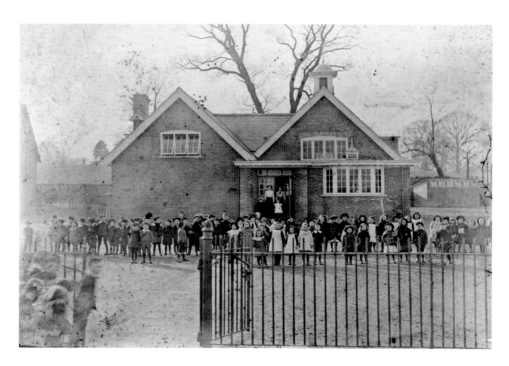

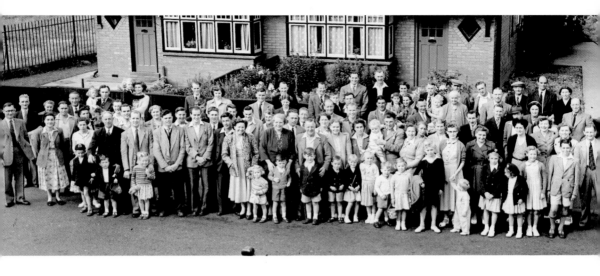

Works Outing in the Late 1950s

Before going on a trip to Brighton, the workers and families connected to Mr Rumble, the builder, gathered outside a pair of houses he had built next door to the infant school in Rectory Road. An enclosed front porch across the two properties has added character, but the two diamond-shaped windows have been hidden in the process. Much of nearby Highgate Lane and Chingford Avenue contain his houses. He named Chingford Avenue after the town of his birth.

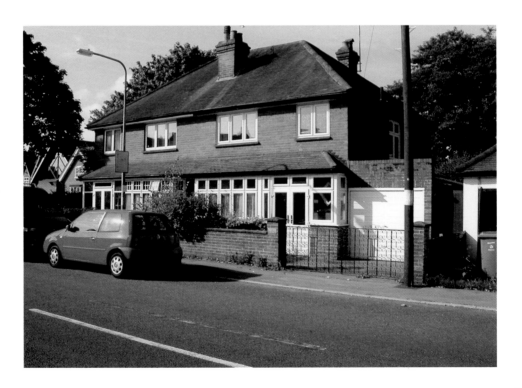

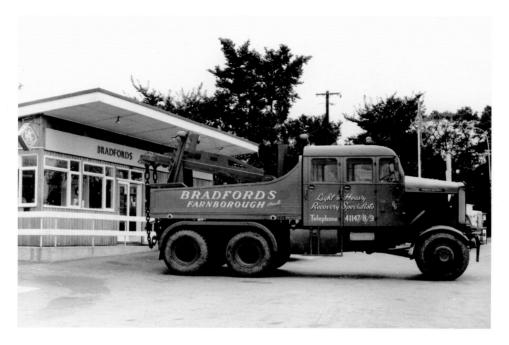

Bradford's Garage

Opened in 1937 by Mr Bradford, with just two petrol pumps, it was the first garage on the approach to the town from the north. It had greatly expanded by the 1960s, seen above, and in the ensuing period has been rebuilt numerous times as a BP garage, the last refurbishment having been completed in August 2009. It is on the corner of Ship Lane, which itself is named after the Ship Inn on the right which dates back to the early 1700s.

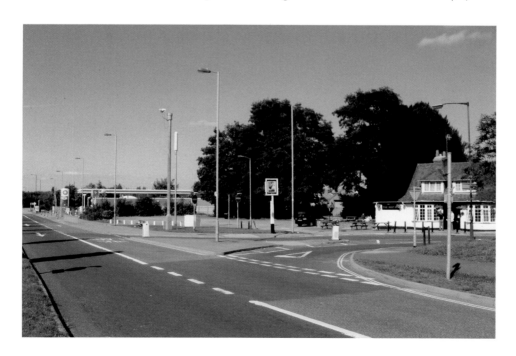

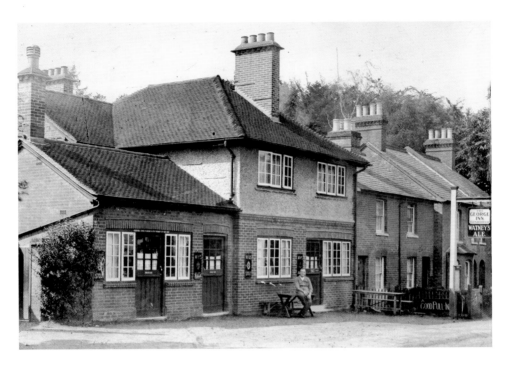

The George Inn

Opposite Bradford's Garage, on Farnborough Road in an area that was known as Farnborough Green, this inn was built in 1873. The licensee's name of J. H. Bissel over the door dates the photograph to the early 1920s. Like many pubs, dwindling patronage caused its closure and subsequent demolition, along with some adjacent cottages, in 1999, to be replaced by new apartments. Far right in the modern photograph is the lodge to the old Farnborough Grange.

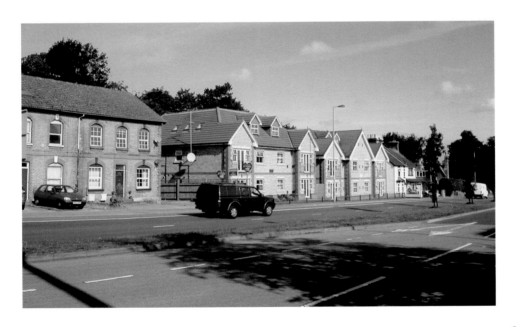

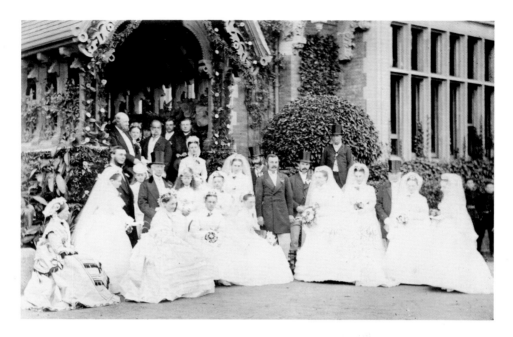

Farnborough Hill Wedding

In September 1869 a society wedding was held in Farnborough when Alice Longman married Captain Hugh Chichester. The wedding breakfast took place at the bride's home, Farnborough Hill, which was built by her father, Thomas Longman, in 1863, and occupied by the family until his death in 1879. This grand house provided an ideal backdrop for the wedding photograph. Legend has it that the myrtle bush seen in today's photograph is believed to have grown from a snippet taken from the bride's bouquet.

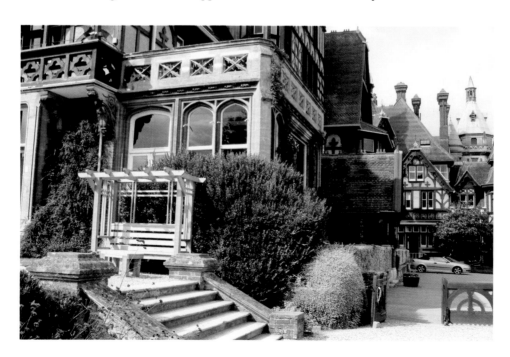

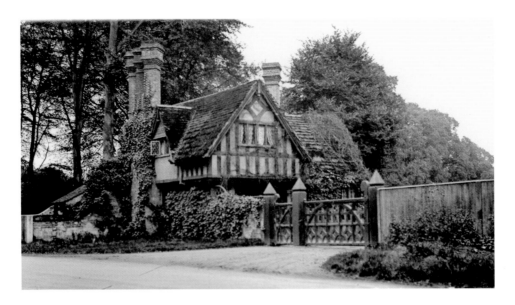

North Lodge

The early photograph of 1916 shows the mock-Tudor cottage built in character with the main house. It was the original entrance to the Farnborough Hill Estate and in the time of Empress Eugénie was occupied by her most senior member of staff, Xavier Ullman. Today it is the caretaker's cottage adjacent to the exit for the present occupants of Farnborough Hill, an independent Roman Catholic day school for girls.

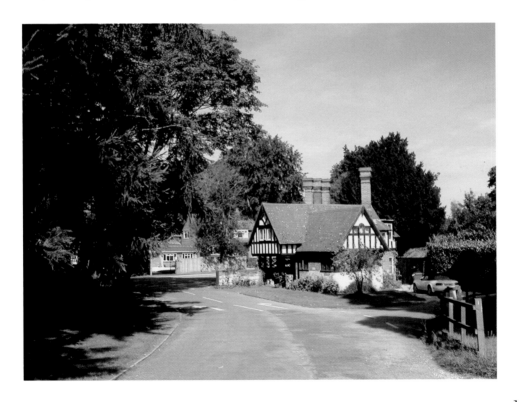

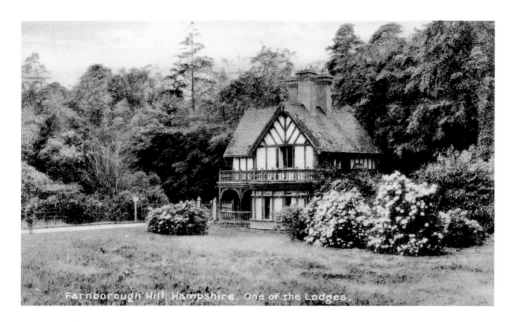

Farnborough Hill, Hampshire. One of the Lodges.

South Lodge

When Farnborough Hill was bought by the Empress Eugénie in 1880, she made considerable alterations. The South Lodge was constructed to become the main entrance, seen here in 1930 after the school took over. It is now the home of the head gardener, seen in the 2009 photograph, who is overseeing a programme of garden restoration. Few people passing on the very busy Farnborough Road realise what a tranquil area lies hidden from view, right in the heart of the town.

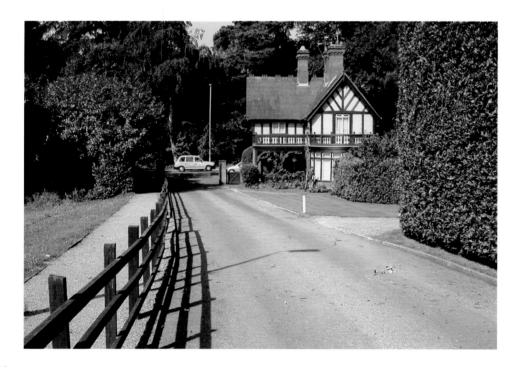

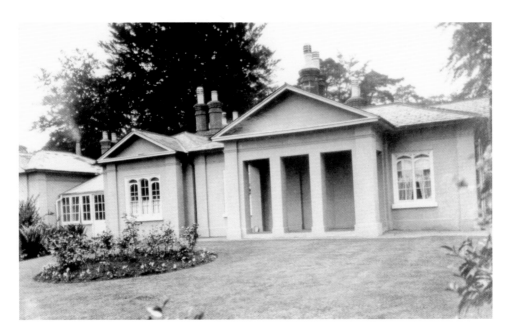

The Pavilion

Formerly called The Lodge, it is on the west side of the Farnborough Road on a piece of land originally belonging to the Farnborough Hill Estate. It is now lost among the new houses of Queen Victoria Court but was originally built in 1819 for Lt Edward Greene, a local benefactor who had retired to Farnborough after being injured at the Battle of Waterloo. He also built three schools and is remembered in the town by a road bearing his name.

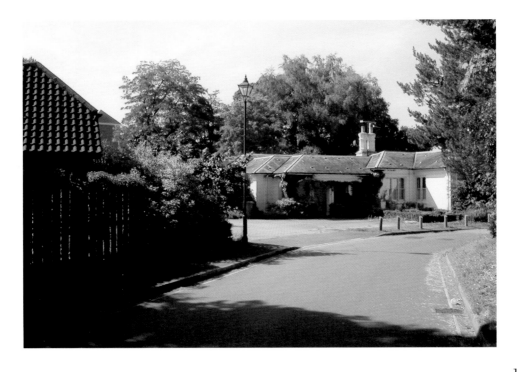

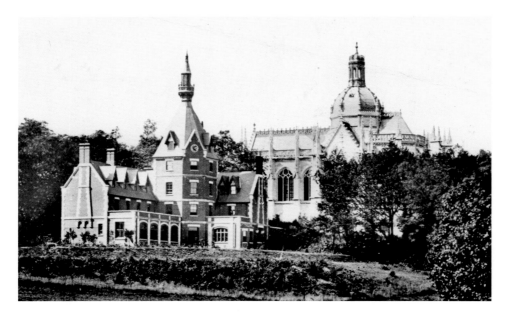

St Michael's Abbey

Built by Empress Eugénie, the monastery, which became an abbey in 1903, was completed in 1887. The following year the crypt became the permanent resting place for her husband, the exiled Emperor Napoleon III of France, and her son, Prince Louis, who had both died whilst the family were living in Chislehurst, Kent. The empress was also buried there in 1920. The inset shows the Imperial Crypt. High on a hill, the abbey is visible from many aspects in the town.

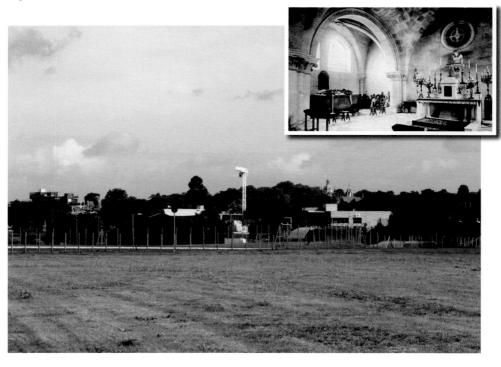

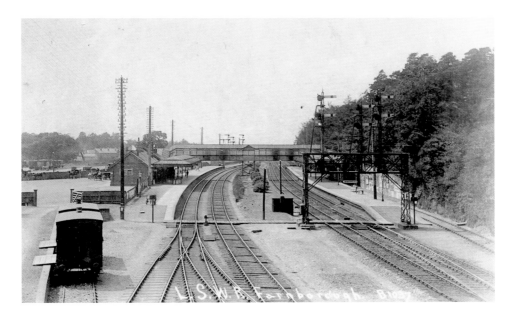

Farnborough Main Line Station

The busy station yard is seen here in the 1930s, with a large coal depot and extra long platforms for military traffic. During the Crimean War, thousands of soldiers passed through to the army camp at Aldershot because the railway did not arrive in Aldershot until 1870. Queen Victoria was a frequent visitor *en route* to reviewing her troops. Today, overshadowed by a large office block, it groans under the strain of all the commuters, but there is no longer any military or commercial traffic.

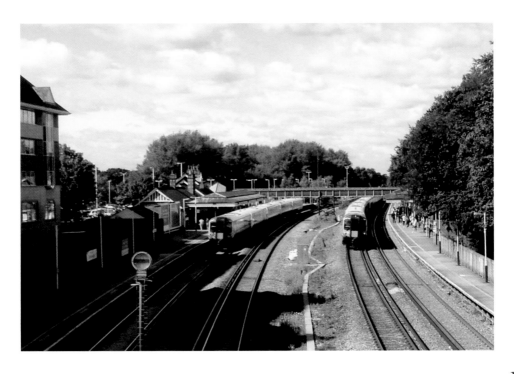

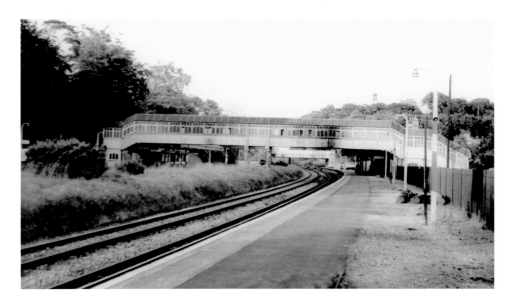

A Bridge Too Far

When Farnborough Station was originally built there were only two tracks. Around 1903, two more tracks were laid and the original two-storey station building was replaced with the present single-storey building. In 1967, the smoke marks of the earlier steam trains were still visible on the footbridge and commuters were able to cross to the up platform without getting wet. The roof was removed some years ago leaving travellers to the mercy of the elements.

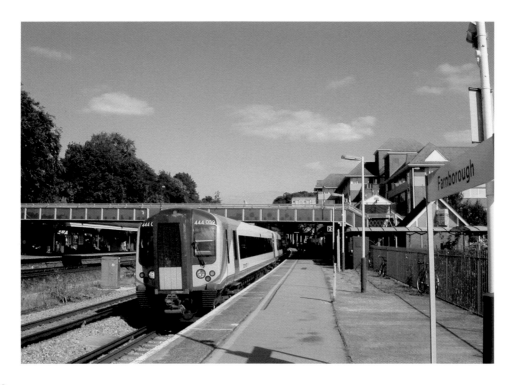

The Ham & Blackbird

Built in 1842 as the New Inn, next to the new railway station, it changed to the Railway in about 1900, and is now a popular Beefeater pub with a modern name. The apartments opposite have replaced the former Cambridge Hotel and Thomson Locals has been built on the site of the old Jubilee Hall and post office building by the bridge. In the 1946 photograph, the Railway was advertising accommodation but that is no longer the case today.

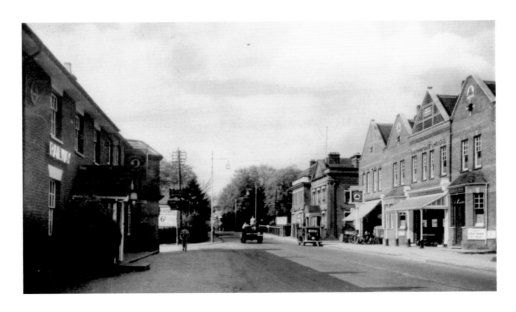

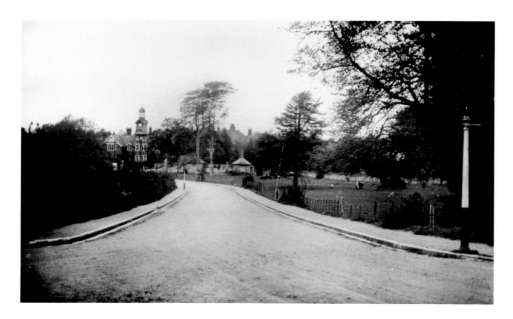

The Clockhouse

This iconic landmark of the town, seen in the distance, was built in 1895 as a private dwelling but is now in commercial use. On the right were the grounds of the Manor House, which, although in private ownership, were popular with local people for picnics in the early 1920s. The two small gatehouses guarded the entrance on the Farnborough Road. Today, mature trees help to soften the large scale building that has taken place over the last ninety years.

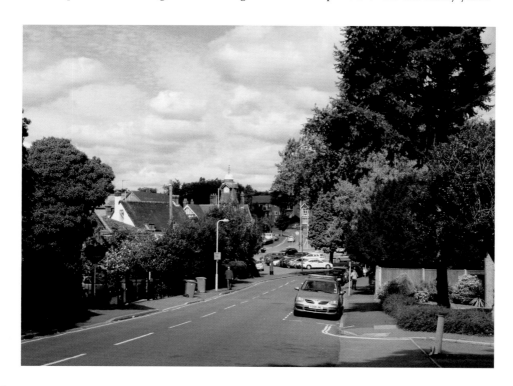

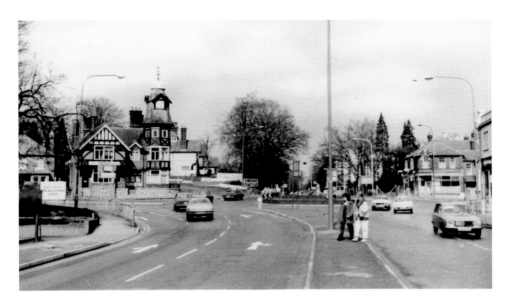

The Clockhouse Roundabout

The first roundabout in Farnborough was constructed on a five-way crossroads in 1952 and has always been adorned with attractive floral displays. The photograph of the mid-1970s also shows that the cupola on the Clockhouse has been lowered because the wooden columns rotted away. Just visible to the bottom right is Kail's grocers which today is Lloyds' chemists, the upper façade of which is the only example of this style of late-1920s architecture in the town.

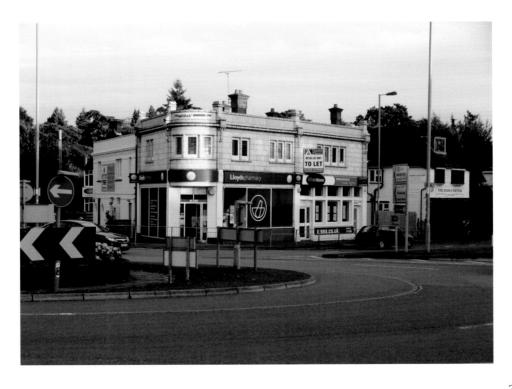

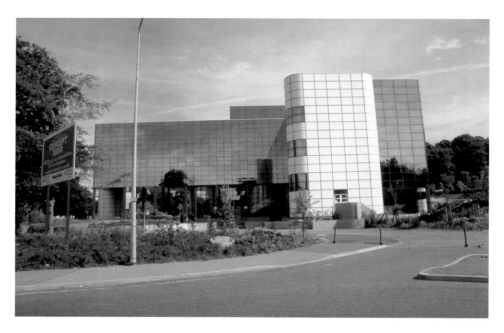

Concept 2000

This impressive glass office building rose up in 1986 on the site of Coombe Farm and a corner block of shops. Against a backdrop of mature woodland and overlooking the Clockhouse, it dwarfed everything around it and created attractive reflections of its surroundings in the glass. Within twenty years it had outlived its usefulness and was demolished to make way for a large-scale housing complex just nearing completion. The first phase is shown here in 2009 at its junction with Rectory Road.

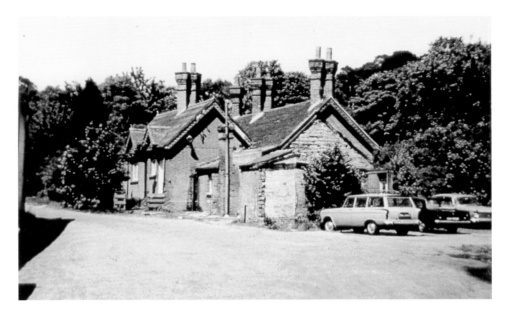

Coombe Farm

It is ironic that when the farm was sold in the 1973, about the time of the above photograph, the council thought it unlikely that permission would be given for offices, although blocks of flats were a possibility. The offices came and went, and the new buzzword in 2009 is 'apartments', some of which are shown here in the centre of the development. Fortunately, the woodland behind is in a conservation area and softens the overbearing effect of such a large concentration of buildings.

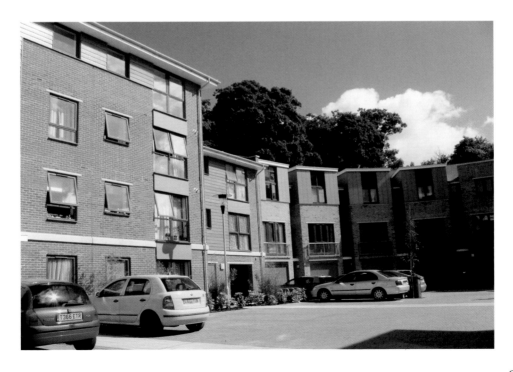

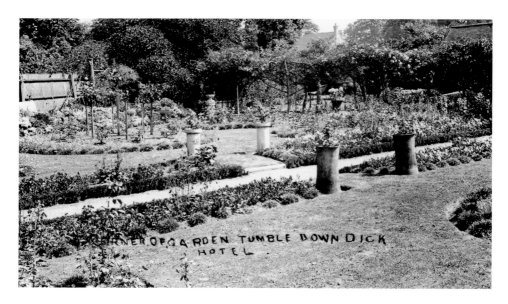

The Tumbledown Dick

Stories of Dick Turpin or Richard Cromwell come to mind, but although its origins cannot be proved, the Tumbledown Dick has featured in historical records for nearly 200 years. Its foundations are probably much older, but this photograph taken seventy years ago shows that this now sad and empty property had the most beautiful gardens as befitted a popular inn, once used for manorial courts. The house in the distance in both pictures is now a dental surgery on Salisbury Road.

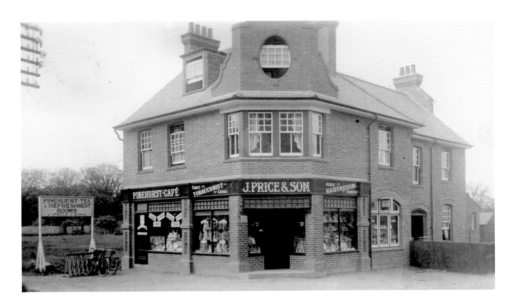

Pinehurst Café

In the 1930s the corner shop café on the junction of Pinehurst Avenue and Farnborough Road was very popular with soldiers from the nearby Pinehurst Barracks. The barracks have long gone and Pinehurst Avenue has disappeared beneath the car park, alongside of which is this large office complex above the entrance to Kingsmead Shopping Centre. Being the first all-glass building in the town, it was very controversial as on dull days the dark glass panels seemed very overpowering.

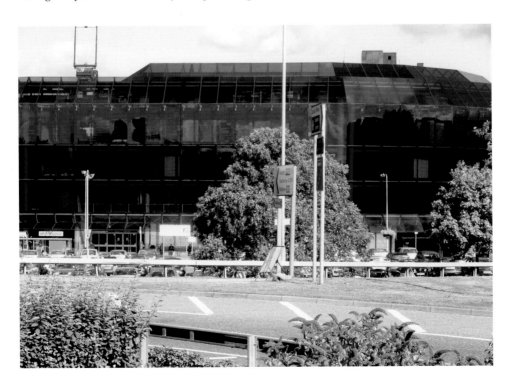

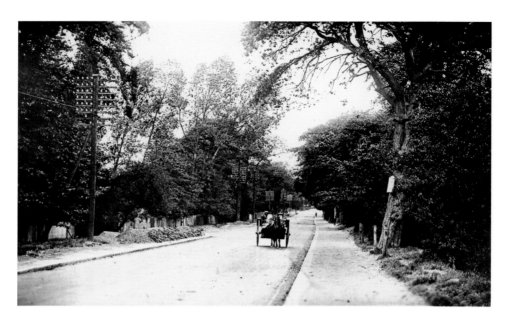

Star Hill on Farnborough Road

The busiest road in Farnborough was surprisingly quiet, with a lone dairyman making his deliveries, when this photograph was taken in about 1910. In the days of horse-drawn traffic, extra horses were often needed to pull heavy loads up the hill. This part of the road, which took its name from the former Star beerhouse, still exists to serve local residences, alongside a new dual carriageway which takes all the main traffic.

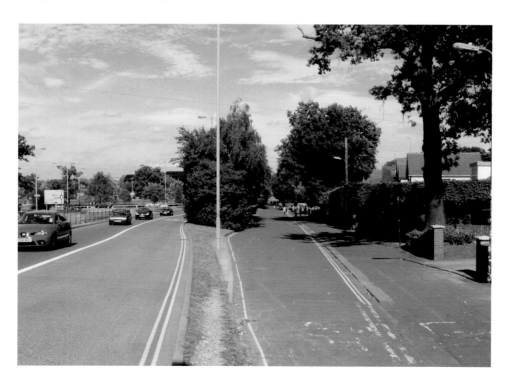

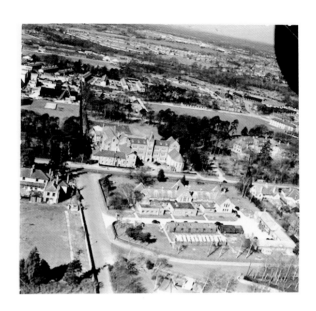

The Old Hillside Convent

The old convent, top left in this aerial view of 1946, was by then the RAE Technical School, forerunner of today's College of Technology. Forest Lodge, right of the convent, has been replaced by the council offices. Belgrave House School on the left and the former secondary school in the centre have made way for new college buildings. Pinehurst Park is the new name for the old convent which, with additions, has now been converted into commercial offices.

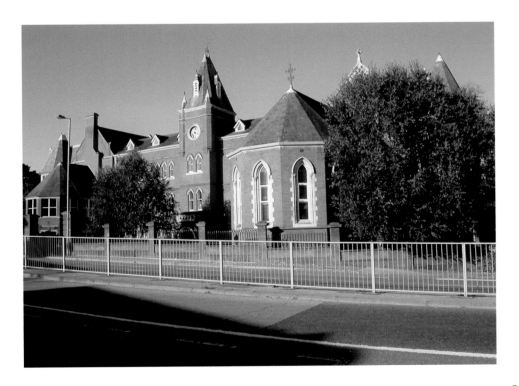

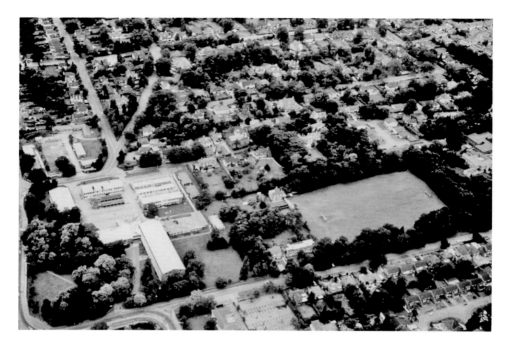

Farnborough College of Technology

Another aerial view, this time from the early 1970s, shows the new buildings of the college, bottom left, on the corner of Boundary Road. At that time, there was still a large sports field and a few private houses on the site. As can be seen today, the college, which is affiliated to the University of Surrey, has expanded across the whole site and is also building a new wing immediately to the north on the Farnborough Road.

The RAE Assembly Hall

This very popular hall was within the grounds of the Royal Aircraft Establishment but had to be closed when the government sold the site. It was demolished along with many other buildings which can be seen on the 1970s photograph of the junction of Boundary and Farnborough Roads. One benefit resulting from the site clearance is that it has opened up the view across the airfield which had been hidden from the public for nearly a century.

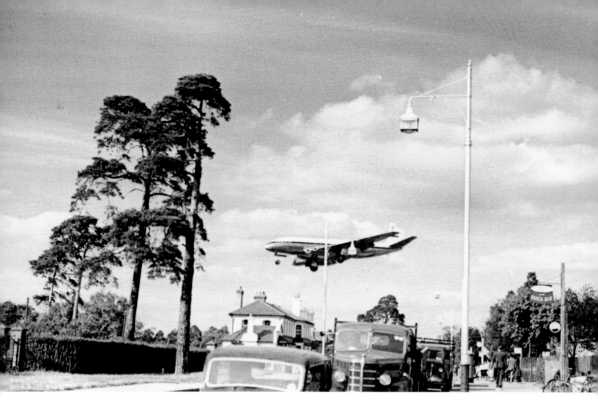

Flying over the Swan Inn

In 1954, the Comet flying into Farnborough Air Show directly over the Swan Inn depicts a scene which has been enacted over the inn since the inception of flying in the early part of the twentieth century. The airfield, which was formerly part of the RAE where experimental flying took place, is now owned by TAG, and apart from the bi-annual airshow, the airport is used solely for business aviation.

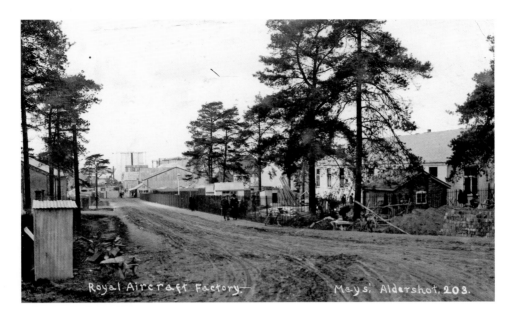

Royal Aircraft Factory— Mays' Aldershot. 203.

RAE Road

The Royal Aircraft Factory, seen here in 1914, rapidly expanded from being the Balloon School in 1905, to a factory manufacturing aircraft during the First World War. It became the Royal Aircraft Establishment in 1918. Over 5,000 workers were employed, including many graduates and scientists undertaking experimental work. Between the wars, the workforce was scaled down but the RAE remained the major local employer until the 1970s. Today this road beside the Swan only gives access to the adjacent FAST Museum.

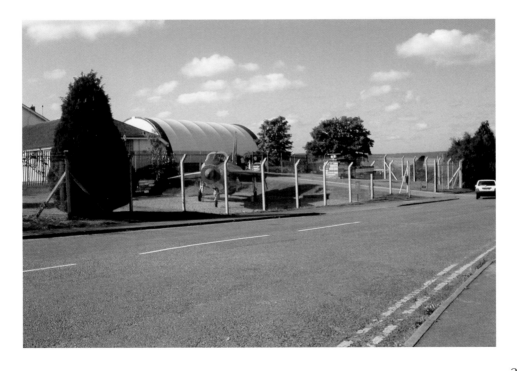

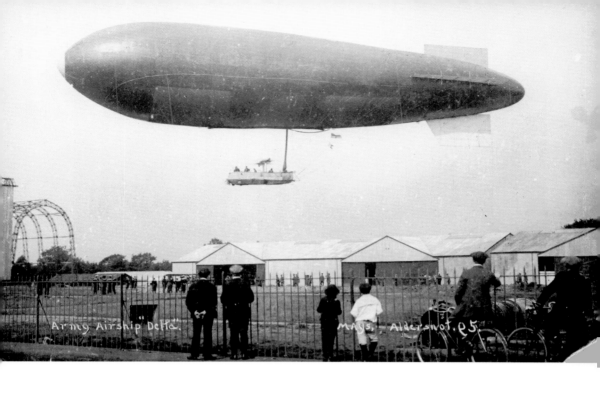

Army Airship "Delta". MAYs. Aldershot. P.5

The Army Airship *Delta*

The new airship was attracting interest when the common was still open for all to enjoy. Gradually, the common was fenced off to protect the security of the government property. The sheds were originally constructed for the army aircraft trials at Larkhill, in 1912, soon after which they were moved here to become Royal Flying Corps workshops. Current workshops and hangars constructed by TAG on the airport are a far cry from those early days of flying.

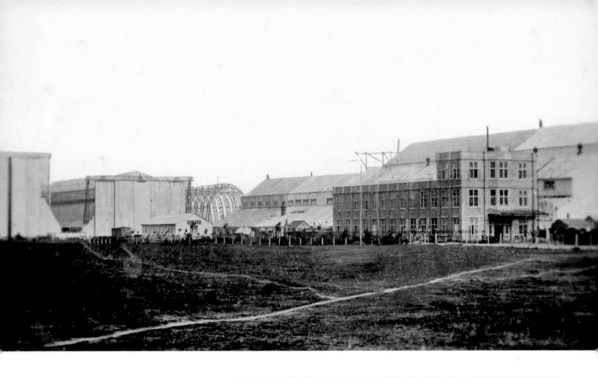

Early Buildings at the RAE
Gradually the RAE expanded, with makeshift buildings being built as and when the need arose. The bare structure of an early airship hangar can be seen in the centre. This was dismantled in 1912 soon after the above photograph was taken, and incorporated into two new workshops. These were subsequently demolished and the original hangar structure, now refurbished, is in a new position, forming a spectacular focal point for the IQ Business Park.

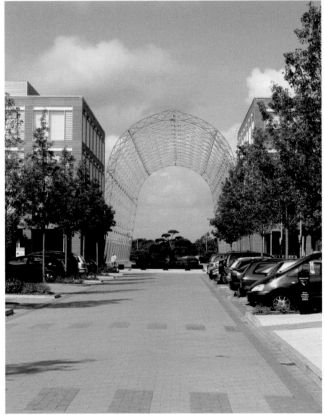

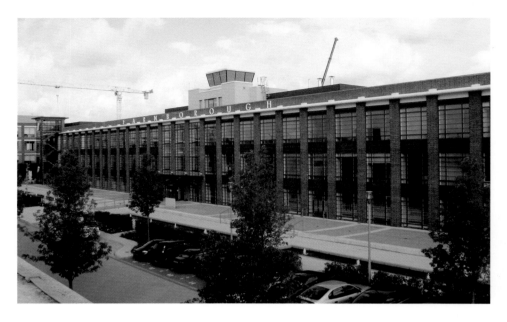

The Hub in the IQ Business Park

The public had no access to this government research establishment and even the employees were unaware of the work being carried out by their colleagues in other departments. Many of the buildings in the aerial view of 1969 have been demolished and new ones are being built, as evidenced by the cranes. Others have been listed and are being restored. The former weapons testing building has been converted into The Hub which is at the heart of this multi-award-winning business park.

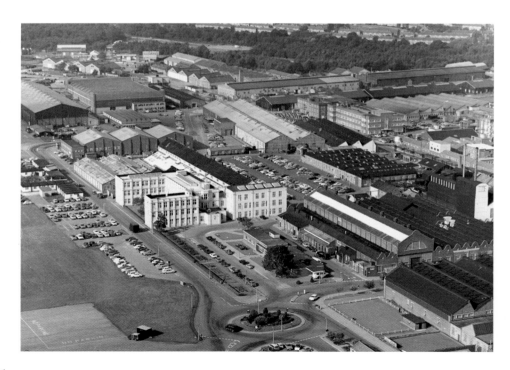

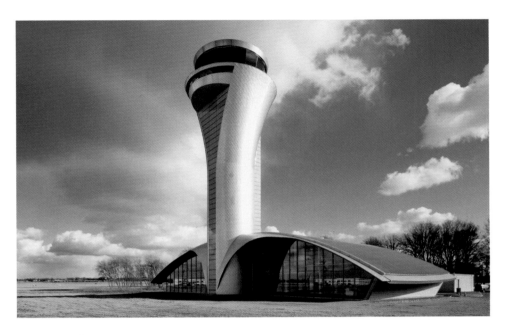

The Control Tower

This stunning piece of innovative architecture is considered to be one of Britain's best new buildings. It epitomises the new futuristic look of Farnborough Airport and has won many design awards. The contrast with the old control tower of the RAE could not be greater when comparing the two photographs. The old tower so familiar to early airshow visitors is seen here in 1963 with the S-R Princess flying boat making an appearance.

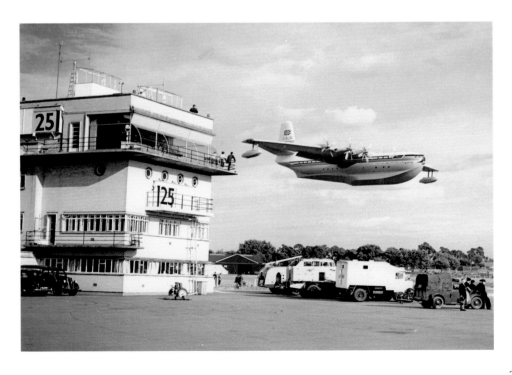

RAE Gate on Meudon Avenue

In the mid-1970s this gate had become the main entrance to the RAE. It was known later as the DERA gate when the establishment underwent yet another name change. The crest on the wall is from the coat of arms granted to the RAE in 1954. The area behind, having been sold off by the government, is now the IQ Business Park, with a prestigious new De Vere Village Hotel set in a well-landscaped setting.

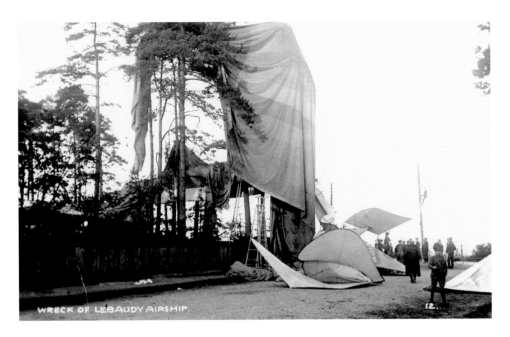

WRECK OF LEBAUDY AIRSHIP. 12.

The Lebaudy Airship Wreck in 1911

Fortunately, no one was hurt when an airship was swept into the trees of Woodland Cottage on the junction of Reading Road and Farnborough Road. There is less likelihood of anything drifting across the road today, because on the opposite side of the road the prestigious Aviator Hotel, owned by TAG, has recently been opened. Viewed from incoming aircraft, the hotel roof looks like an aeroplane propeller.

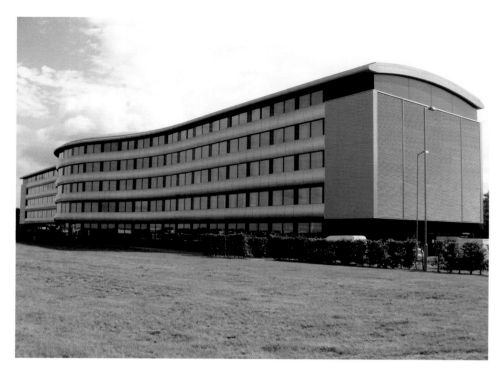

The Aviator Hotel

The back of the hotel gives impressive views across the airfield but few visitors realise that before the First World War hospitality of a different kind was available on this part of the common. Every summer thousands of officer cadets from public schools across the country arrived for Officer Training Camps. Their facilities were all under canvas including giant mess tents and shops. A temporary W. H. Smith & Son bookstall can even be seen.

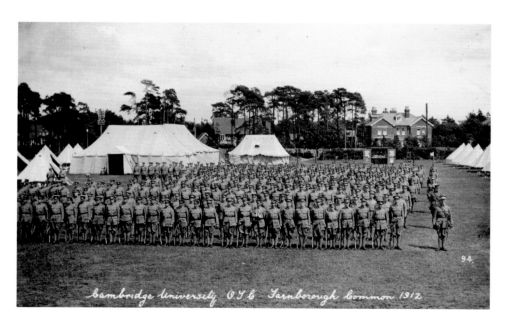

Cambridge University OTC Farnborough Common 1912

Farnborough Road Looking Towards The Swan

The northern and southern approaches along the main road thorough the town still retain a corridor of trees as in former years. Here at the junction of Reading Road there is now a cycle path but bollards restrict motorised access from the right. By contrast the same view in 1909 shows the remains of the tramway on the left between rows of telegraph poles, mud everywhere, no pavements and a single crude gas streetlight.

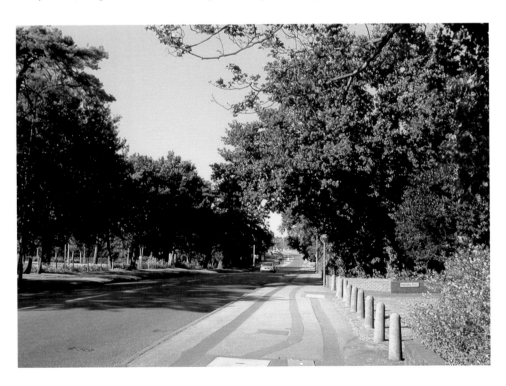

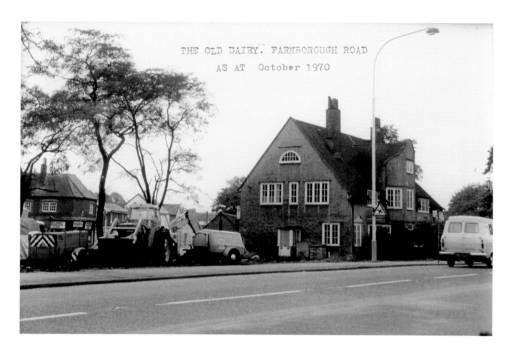

THE OLD DAIRY. FARNBOROUGH ROAD

AS AT October 1970

Deepcut Dairy

This photograph was taken in 1970 just before the bulldozer got underway. The dairy was built in 1904 on the Farnborough Road and incorporated tea rooms which had fantastic views across Farnborough common. When an entrance to the RAE was built, immediately across the road, it became known as Dairy Gate. The present 1970s-style houses no longer have to suffer low-flying aircraft as warned in the earlier photograph, as the former nearby runway is no longer used.

Farnborough International Venue and Events (FIVE)

After sixty years Farnborough now has a permanent exhibition venue, although thousands of square feet of temporary buildings are still erected for every airshow. A temporary structure of a different nature was the field kitchen set up on the edge of the airfield during the Second World War to be used in case there was a large influx of evacuees. With few real weapons available for home use, wooden machine guns were strategically placed so that enemy reconnaissance aircraft might be fooled.

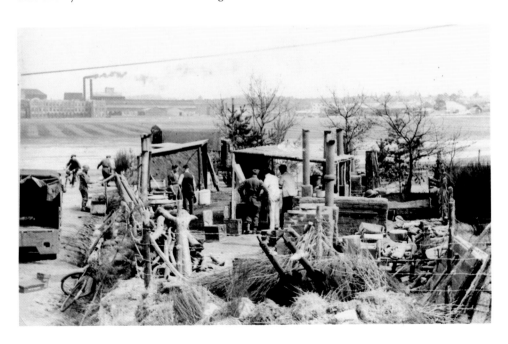

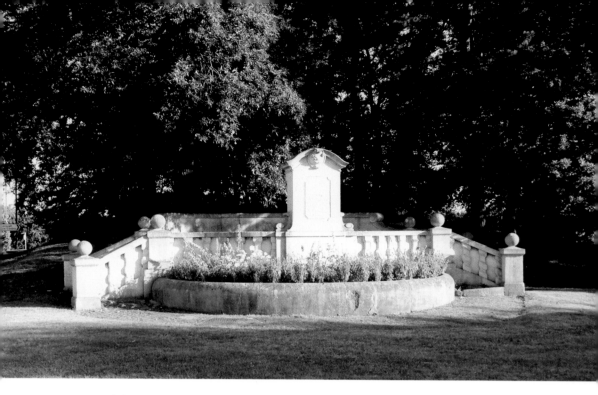

Memorial to an Unknown Soldier

At the southern end of the town, where Lynchford Road joins the Farnborough Road, this memorial was erected in 1902 and dedicated to soldiers of the Boer War. Behind it lies an ancient burial mound with the legendary name of Cockadobby. With a redundant plant-filled horse trough and disused drinking fountain, it now forms part of the Queen's Roundabout close to the Holiday Inn.

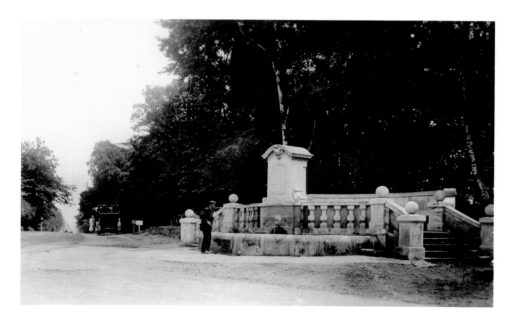

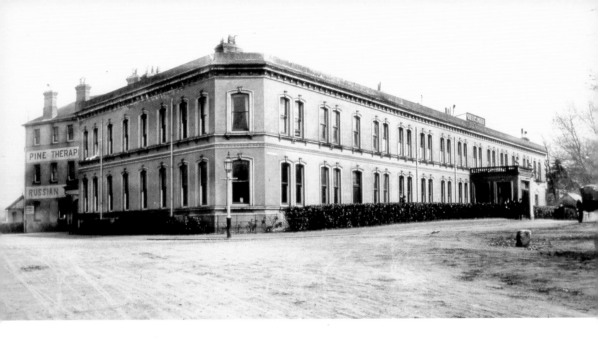

The Queen's Hotel

The hotel was built in 1855 as a rectangular wooden building to accommodate officers and visitors to the new army camp. Clad in bricks in the 1880s, it was destroyed by fire in 1902 and was rebuilt the following year in the Edwardian style we see today. For many years it was the only large hotel in the town, and in 2009 it is still locally referred to as the Queen's, despite its name change to the Holiday Inn.

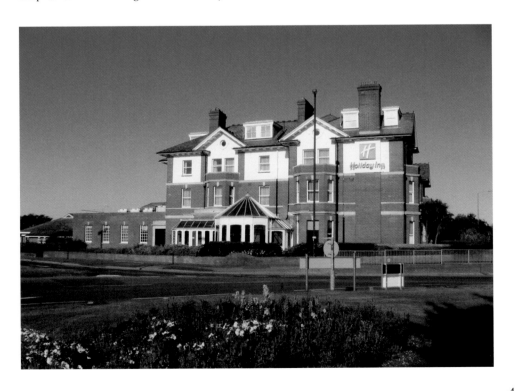

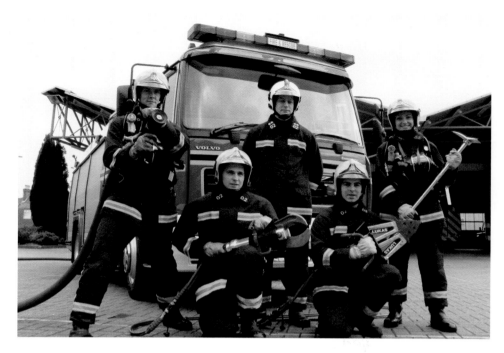

The Fire Station

This is the fourth location for the fire service which started off using a large shed in Camp Road in 1899. The council built a fire station at the old town hall in 1905, where the 1934 photograph was taken. In the 1960s they moved to Reading Road and in 2010 they will celebrate twenty years at the present Lynchford Road premises. The retained (part-time) firefighters in the 2008 photograph are the direct professional descendants of the Farnborough firemen of previous times.

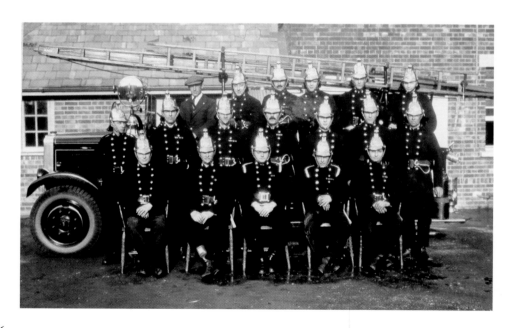

The Police Station on Lynchford Road

These police quarters were built in 1898 next door to the London & Counties Bank, now Natwest, which is the large building on the right. The stables and yard were at the back of the building. When the new police station was built in the 1970s, near what is now the town centre, these buildings were demolished to be replaced by a development named Peel Court after Sir Robert Peel, the founder of the police service.

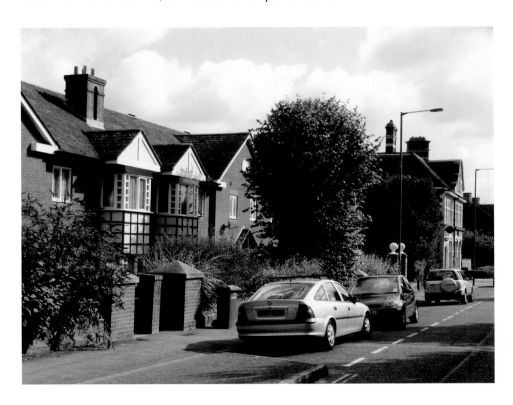

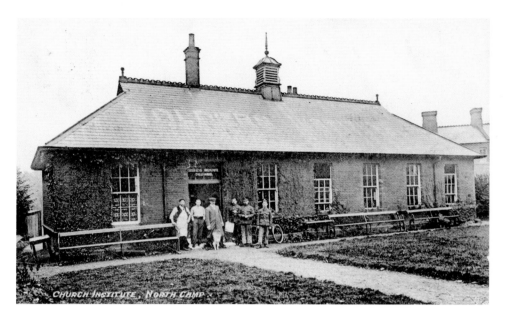

The Soldiers' Institute, North Camp

On Lynchford Road, opposite the junction with Alexandra Road, this was a place where the soldiers from the camp could go for 'home comforts' which could not be provided in their crowded barracks. It was later enlarged to provide bathing facilities, reading rooms and a chapel. The words 'Soldier's Home' on the roof have faded with time and the building is now in commercial use.

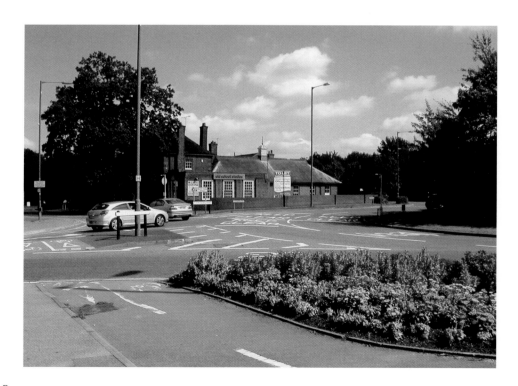

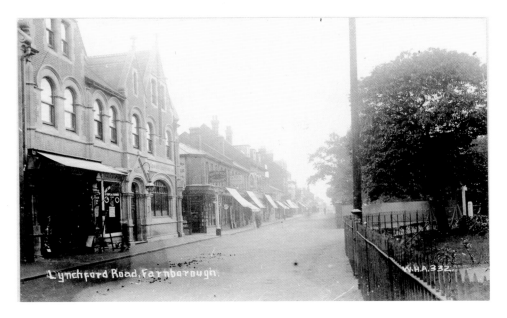

Lloyds Bank Building, Lynchford Road

This was opposite the Soldiers' Institute and occupied by the Capital & Counties Bank, the forerunner of Lloyds. Next door, in the centre of this photograph taken in 1911, is Litchfield's Pharmacy which opened in 1879 with Mr Litchfield as manager. It remained a pharmacy until it closed in 2007 when astonishingly some of the original drawers, seen in the inset, still existed within the shop. It has now reopened as a hairdressers.

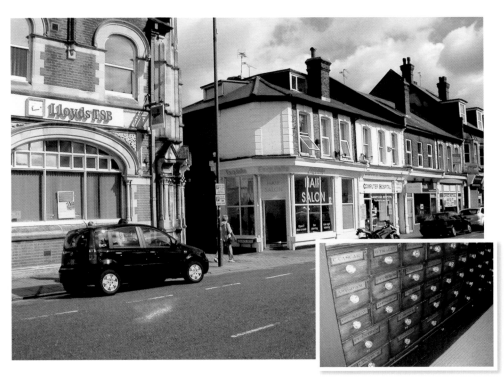

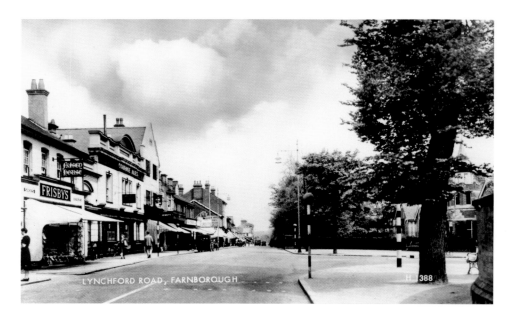

Frisby's Shoe Shop

Originally these shops served the army population from the camp opposite. There were seven boot and shoe shops along this stretch of Lynchford Road. In the 1950s only Frisby's remained and that has now become an amusement arcade. Hewett the butcher, a few doors along, has also gone, but the inset from 1934 indicates the level of custom in this once-thriving shopping area.

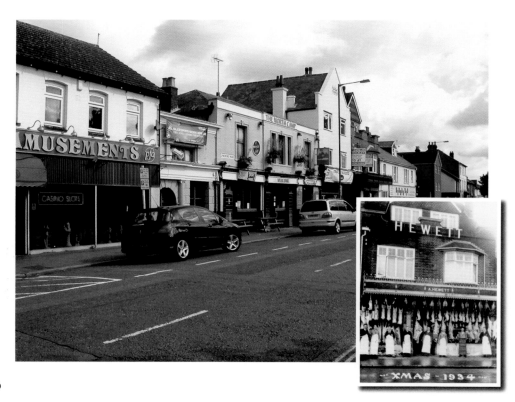

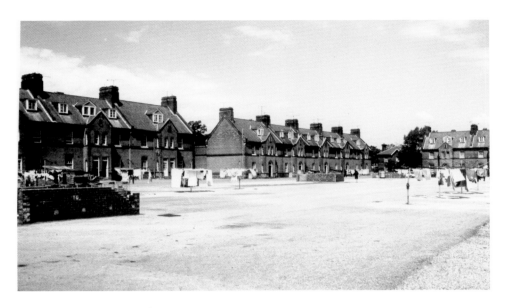

Somerset Square, North Camp

When the soldiers first moved into North Camp in the 1850s they were accommodated in wooden huts. Between 1881 and 1898 the huts were gradually replaced with red brick, two and three-storey barrack blocks. Somerset Square, off Redvers Buller Road, seen here in the 1970s, was an example of the drab and depressing quarters provided for married soldiers. By total contrast, the replacement quarters, seen here a little further along the Queens Avenue, are much more pleasant to live in.

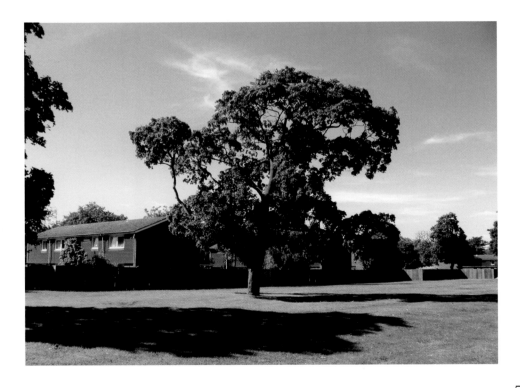

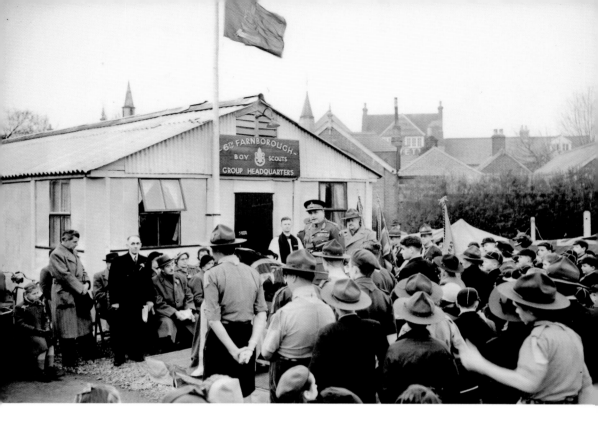

The 6th Farnborough Scouts Troop

In 1952, a new headquarters for the 6th Farnborough Scouts was opened behind the former Wesleyan Soldiers' Home on the corner of Lynchford Road and Queens Avenue. Both the home and the scout HQ have now disappeared and this end of Queens Avenue has been grassed over. The scouts' present hut is off Cheyne Way beside the motorway, and in 2009 it is a sad reflection of modern times that it has to be enclosed in security fencing to deter vandalism.

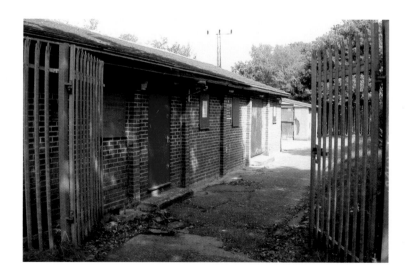

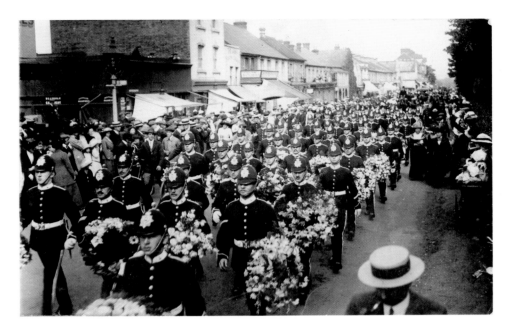

Col Cody's Funeral

Samuel Franklin Cody achieved the first recorded powered flight in Britain at Farnborough in 1908. He died when his aeroplane crashed on the airfield in 1913. Thousands attended his funeral and here the precession is passing the junction of Peabody Road and Lynchford Road. The single-storey shop on the corner has since been replaced by a two-storey building, but for the remainder, apart from a change in the type of shops, the street scene has changed little in the intervening years.

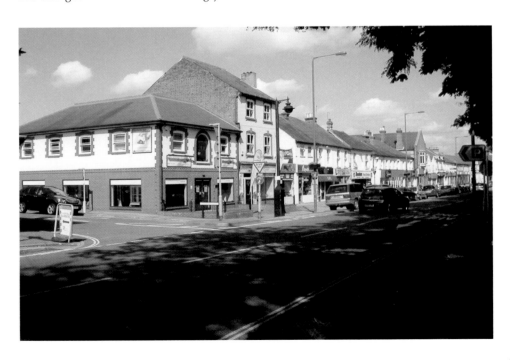

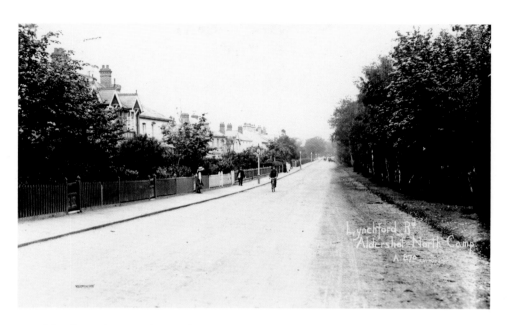

Lynchford Road Towards North Camp Station

What appears to be a muddy area on the right of the road is where the tramlines had recently been removed around 1910. In the late nineteenth century, a horsedrawn tram had been in use between Farnborough Main Line Station and North Camp Station, both stations being on separate railway systems. The road now is purely for access to the houses, with the main road having been re-aligned to the right of the trees.

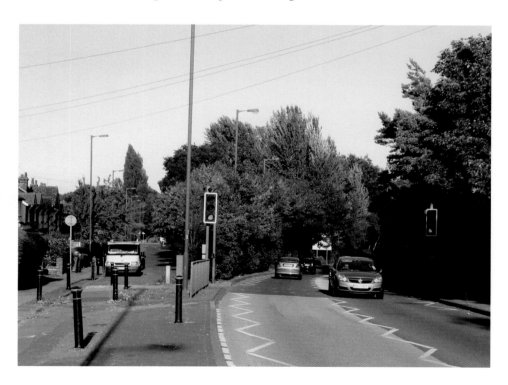

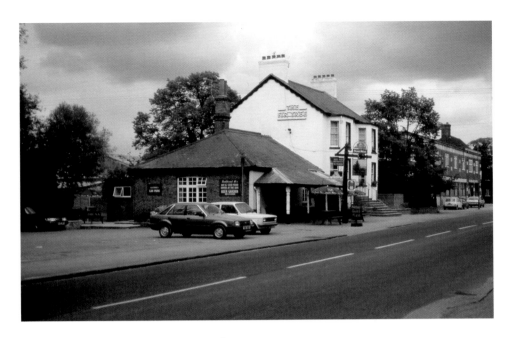

The Fir Tree Near North Camp Station

Still with some customers in 1989, when the above photograph was taken, the final blow to the dwindling patronage of this old pub was the construction of the adjacent Blackwater Valley Road junction. The low structure to the left was believed to be the ticket office and waiting area for passengers using the horse-drawn tram. Now, this forlorn-looking building seems a little out of place in a semi-industrial area.

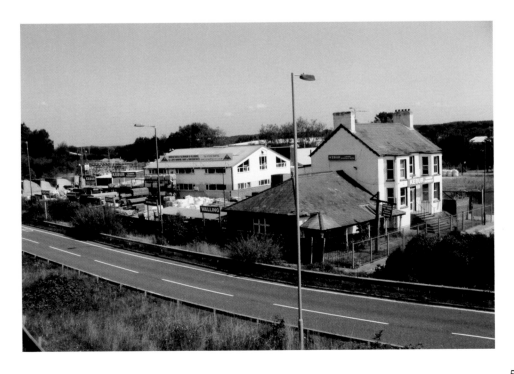

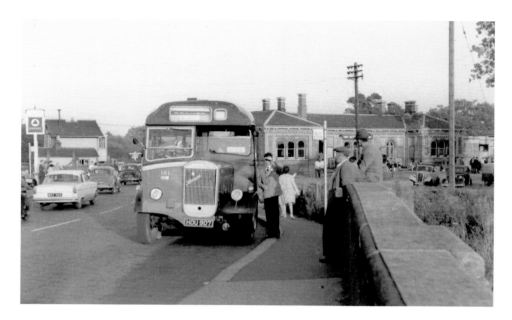

North Camp Station

The bridge over the Blackwater River took Lynchford Road across the county boundary into Surrey. The cars are waiting at the level crossing beside North Camp Station and the bus is collecting passengers for the air show in 1960. The bridge is now hidden beneath the structure of the Blackwater Valley Road and Lynchford Road has been re-aligned. Heavily overgrown trees mean that the station and the Old Ford pub next door are barely visible.

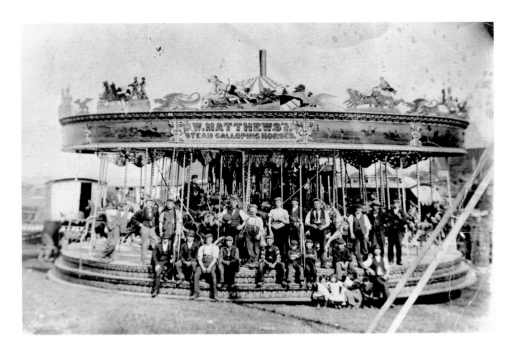

Matthews' Steam Gallopers at Gravel Road

Farnborough has had a long relationship with fairground folk who have been based in the town for over a century. These steam gallopers, built by 'Redshirt' Matthews in 1880, were a popular attraction at events across the country, but none more so than at the military fêtes held in the nearby grounds of Government House. A different set of gallopers, seen in the lower photograph, are owned by Tommy Noyce, whose ancestors were among the group photographed on the earlier ride.

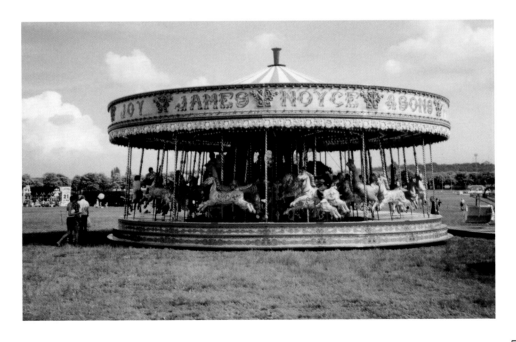

Rag Day Parade in 1955

The students from Farnborough College of Technology are taking part in the Rag Parade along Camp Road. The rag weeks were organised as a means of having fun and raising money for charity but they ceased some time ago. In recent years there has been a revival of a parade at the annual North Camp Fayre. The British Legion Band is leading the parade in 2009 as it passes the former premises of Thomas White's Department Store, now the Manhattan restaurant.

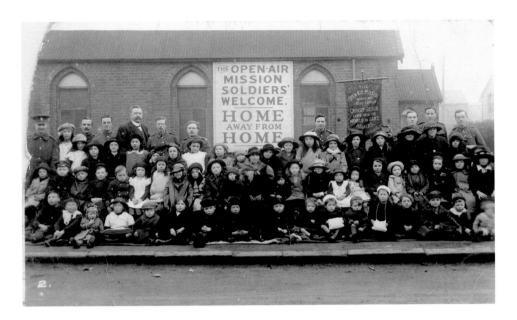

Open Air Mission

This slightly damaged photograph, taken about 1910, shows the first Mission Hall built by Helek Beagley in 1896 on Queens Road, opposite the end of Somerset Road. Later, a new Mission Hall was built further along Queens Road, which enabled the original building to be used by the Open Air Missionaries as a Soldiers' Home. The shops seen in the current photograph were built in the 1920s but the roof of the old hall, now a dance studio, is clearly visible behind them.

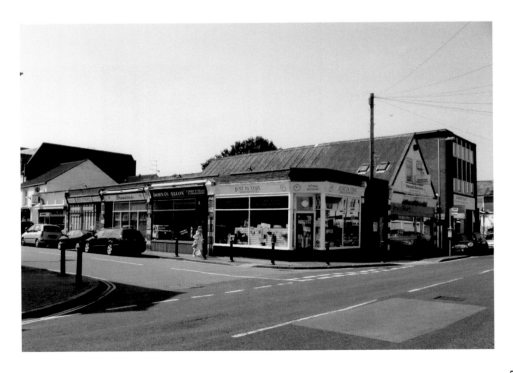

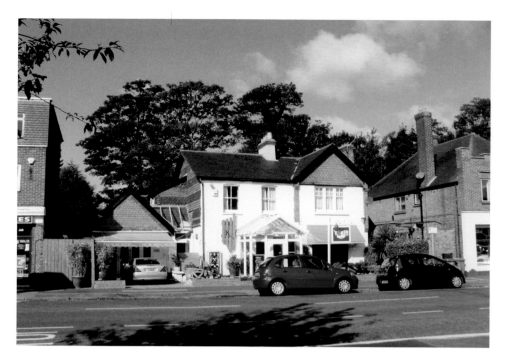

Wings Cottage

Wings Cottage in Alexandra Road now occupies the former lodge to Tredenham House which was built by Colonel Carlyon in the late nineteenth century. The main house was demolished in the 1960s. Below is a postcard from the 1970s advertising the restaurant when it was the Inglenook, so named because of the fireplace. Various extensions, including the one on the left over the driveway to the main house, have enlarged the restaurant area but the fireplace still remains.

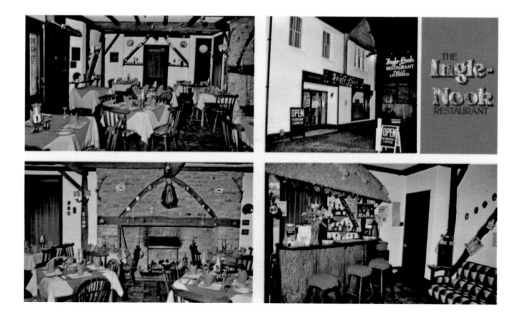

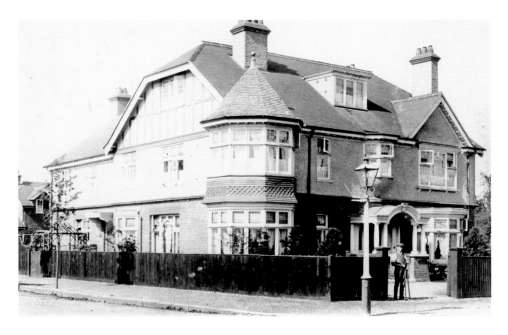

The Wykeham Hotel

This hotel next to Cross Street became empty in the 1980s and was systematically destroyed by vandals, necessitating demolition. These older buildings gave character to the road and fortunately quite a number still remain. The present block of apartments endeavours to blend in and is now shielded by the adjacent trees.

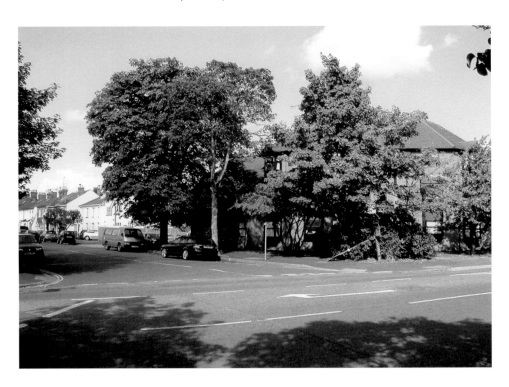

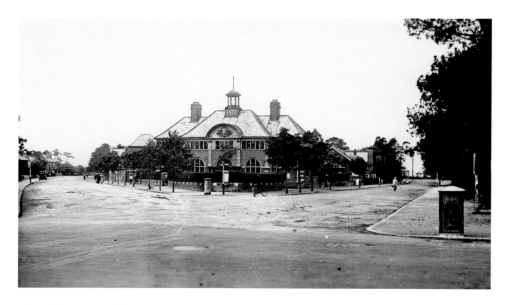

The Old Town Hall *c.* 1909

Built in 1896 where Guildford and Reading Roads join Alexandra Road, it was strategically placed between the old village in North Farnborough and the rapidly-expanding area of South Farnborough and North Camp. Many people will remember the popular dances held there until the late 1970s. It became surplus to requirements when the present administrative offices of the council moved to a more central area among the trees on the corner of Meudon Avenue and Farnborough Road.

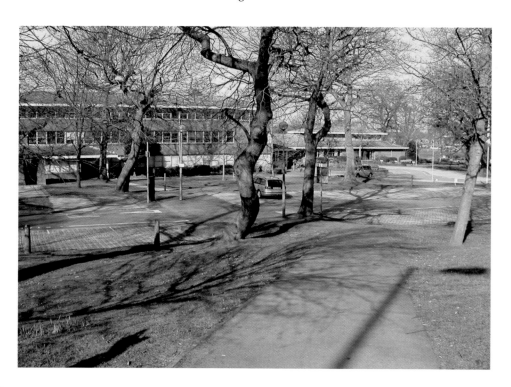

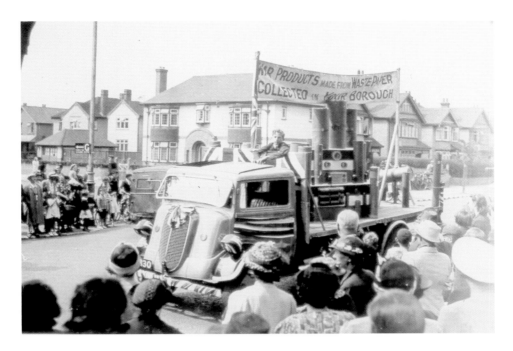

Recycling Parade

The people of Farnborough are no strangers to recycling as demonstrated in 1942 with a parade to encourage recycling for the war effort. The houses here near the old town hall, having been built in the early twentieth century, illustrate the progression of development towards the central area of the town. Recycling today is on a much greater scale, with different coloured bins, boxes and bags for sorting our waste. One or two bins have crept into the photographs of this book. The roundabout is the one mentioned over the page.

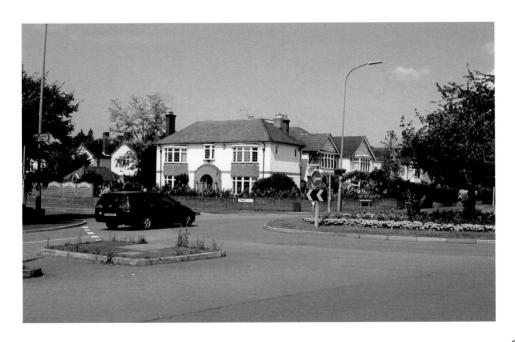

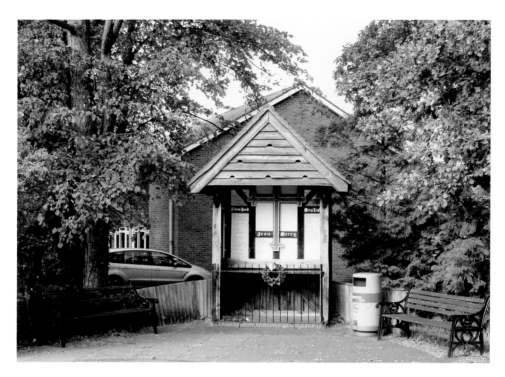

St Mark's Church War Memorial

The church was consecrated in 1881 to serve the spiritual needs of the people of South Farnborough. The wooden war memorial was erected to commemorate those who had who had fallen in the First World War. When the road was widened for a roundabout in the early 1960s, the memorial was moved to its present position on the opposite corner of the road, in the grounds of the church hall.

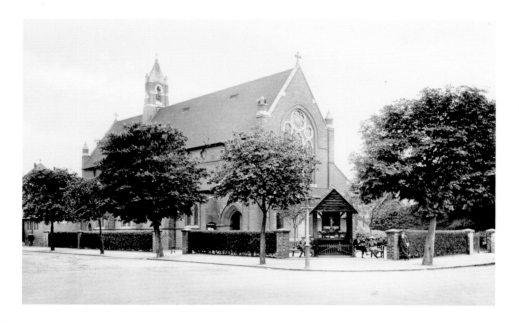

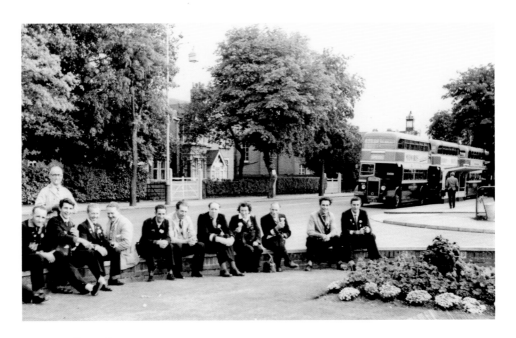

Town Hall Gardens

The gardens, within a low circular wall in front of the old town hall, are always an attractive area in which to sit. In September 1960, they were a welcome resting place for the bus crews between duties ferrying visitors from the railway station to the air show. In 2008, the shuttle service travelled along the Farnborough Road, as is seen here passing the FAST museum.

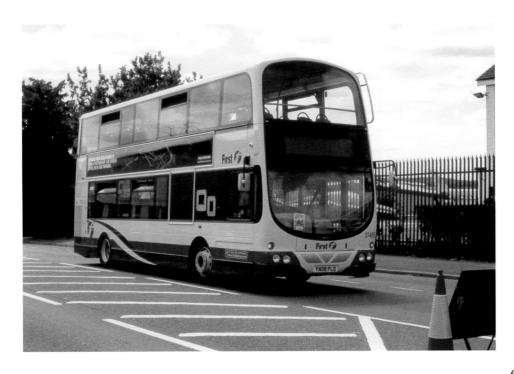

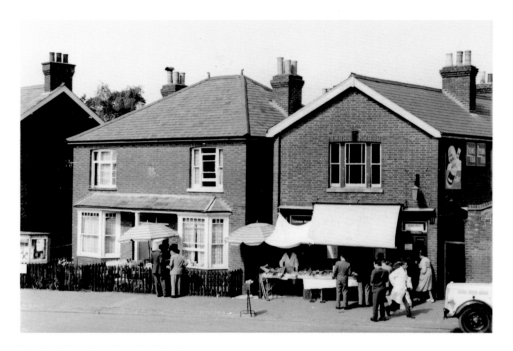

Fundraising During the Airshow

The local economy has always benefitted from the airshow, whether it was supplying goods for hospitality tents, offering bed and breakfast for visitors or even renting out parking space in private gardens. Here, in 1964, the scouts were serving drinks and sandwiches to visitors passing Mr and Mrs Winter's grocery shop in Guildford Road on their way to the airfield. The new houses seen in the lower photograph blend into a well-established road.

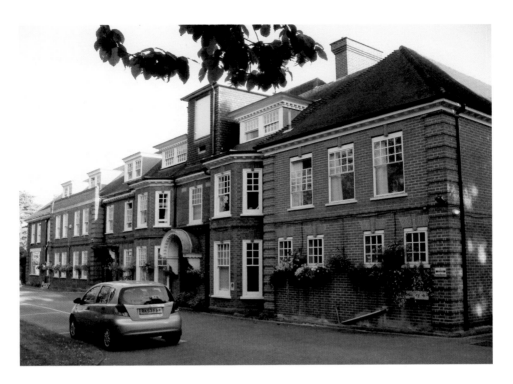

Devereux House

Originally a private house in Albert Road, it became the Cottage Hospital in 1921 when it was purchased by the people of Cove and Farnborough as a memorial to those who had fallen in the First World War. With added extensions it served the town until the new Frimley Park Hospital was built in the 1970s. Redundant as a hospital, it is now a Day Care Centre, with short-stay residential accommodation.

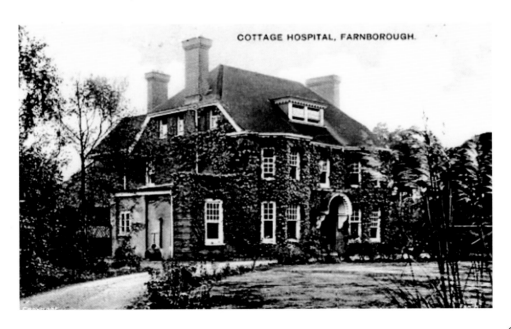

COTTAGE HOSPITAL, FARNBOROUGH.

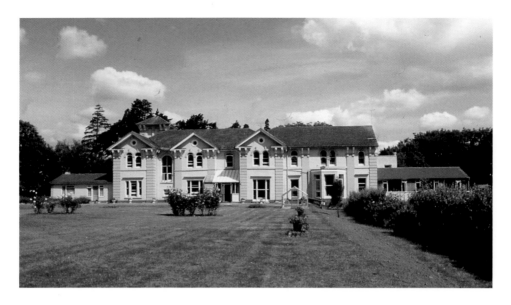

Knellwood Residential Care Home

The above photograph, taken in 1985, shows a Victorian house that had changed little since it was built *c.* 1867. In the early days it was occupied by high-ranking military personnel who entertained quite lavishly. For some years it was a hotel and now, with substantial extensions, it is a residential home for the elderly and is the town's Second World War Memorial. Today, the residents regularly enjoy watching the local U3A playing croquet, emulating a scene from earlier times.

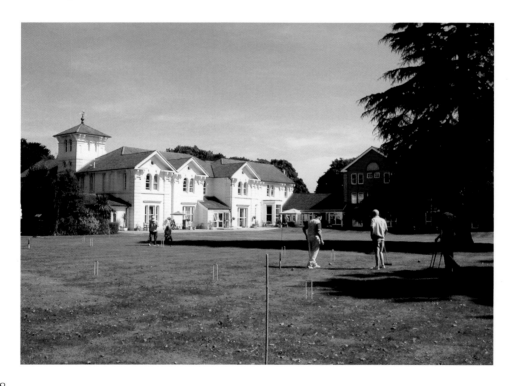

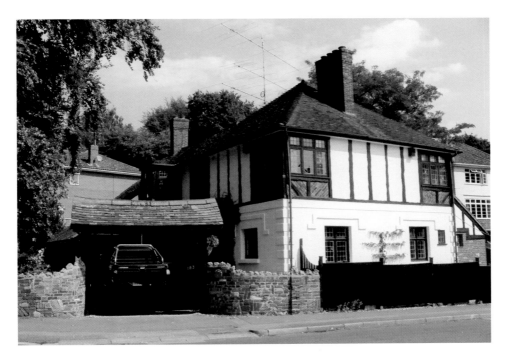

The Old White Lodge on the Corner of Sycamore and Avenue Roads

In 1919, at the time of the lower photograph, this was the lodge attached to The Sycamores, a large Victorian house on higher ground behind the trees. The Sycamores has long gone, and the upper photograph shows that the lodge has been enlarged into a house. The identifying characteristics that remain are the quoins on the corner and the feature over the windows on the lower half of the building.

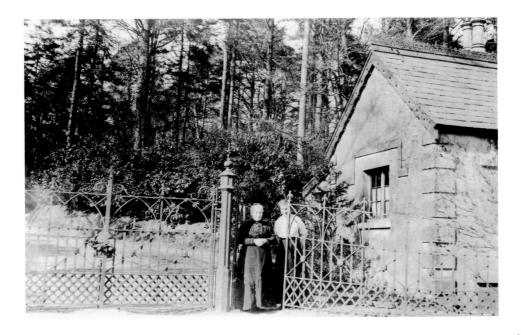

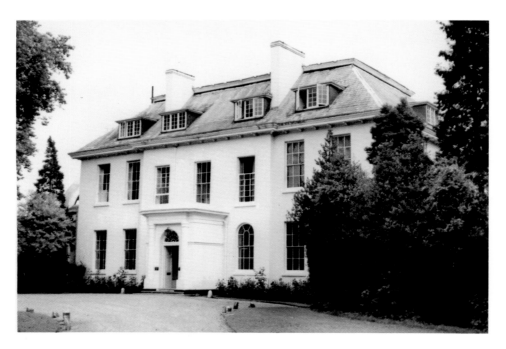

Farnborough Place

For 200 years the lords of the manor lived in this house, reputed to have been designed by Sir Christopher Wren. Having once been threatened by demolition, this listed building is now home to St Peter's Junior School in the grounds behind the church. The earlier photograph, above, was taken before the school took over in 1962, and the inset shows the six-a-side football team in 1965. In 2009, some alterations can be seen on the left, but the trees mask the school hall.

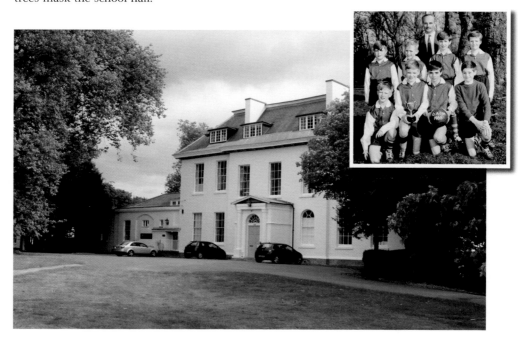

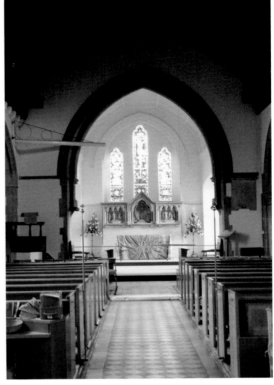

The Interior of St Peter's Church
On Church Avenue, at the top of a hill, stands the church, which dates back to the thirteenth century and is attributed to being the inspiration for the hymn *There Is A Green Hill Far Away*. It has undergone many structural changes and in the early photograph, when the church is believed to be decorated for the peace celebrations in 1919, a wooden screen is visible across the nave. During alterations in 1964, this was removed and placed on the north wall.

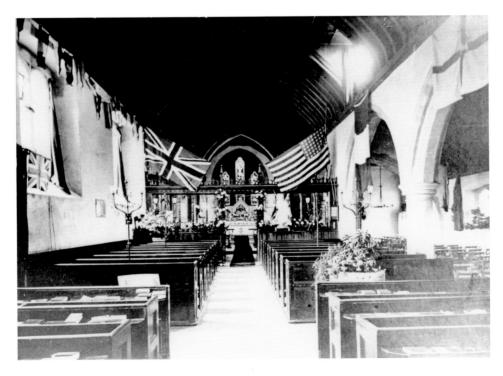

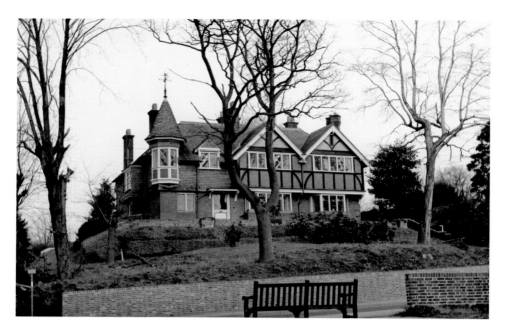

The Chudleigh Hotel

Once a private house, this hotel on Victoria Road was requisitioned by the government as accommodation for some of the early scientists working at the RAE. Their work was crucial to the development of aircraft in the First World War and afterwards a number of them attained professorships and became peers of the realm. The present residential development on the site has been named Chudleigh Court and still has the original pedestrian access onto Victoria Road.

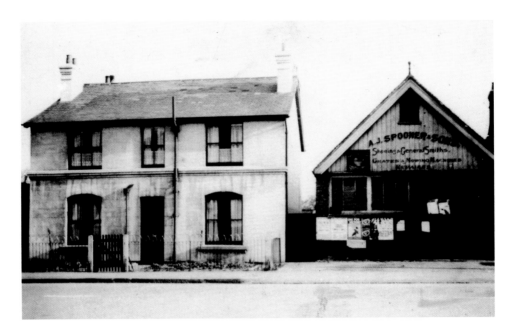

Spooner's Forge on Victoria Road

This rarely-seen photograph shows the forge on the right, with the family house next door. Mr Allan Spooner started the business in 1885 when horses were the only means of transport. The open doors of the forge were a familiar sight to passers-by right into the 1960s, when the business closed. In 2009, the forge has now been replaced by offices and the two remaining houses at this end of the road are now a take-away restaurant.

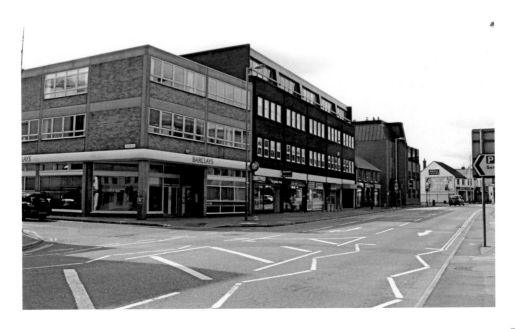

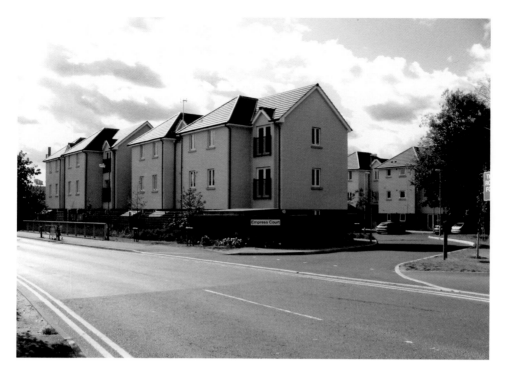

Empress Court

Mr Spooner's forge was on a large plot of land next to Spooner's Lane which gave access to the fields behind. Leading down beside Barclays Bank, the lane has now become Westmead, giving access to the rear of the shops. *Mead*, the old English for field, reflects the earlier agricultural use of the surrounding land. The Spooners, sitting beside all their beehives in the 1930s, would be amazed to see new developments like Empress Court built on their fields in 2009.

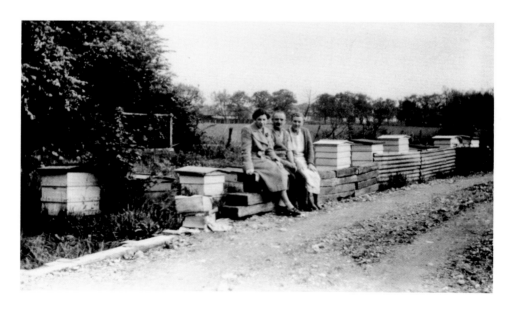

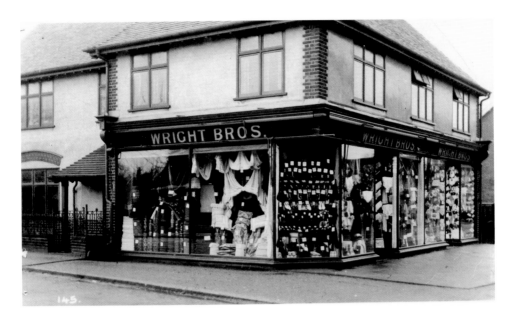

Wright Bros

Victoria Road was a busy shopping area during the first half of the twentieth century mainly serving the people of Cove and North Farnborough. Mr Wright opened his drapery store on the corner of Elm Grove Road in about 1910. Household goods, shoes and lingerie were all displayed to tempt the customers. The shop ultimately extended over four properties and included the sale of household furniture before it was demolished in the 1970s to make way for the offices seen today.

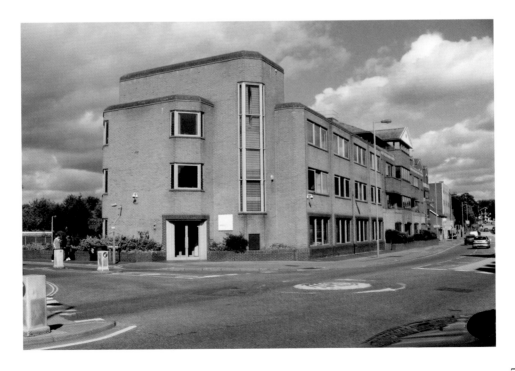

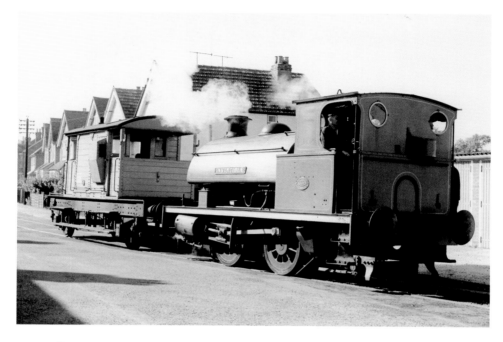

RAE Railway

The train travelling between the RAE and the main line station was preceded by a man with a red flag warning the traffic as it crossed Victoria Road and went along Elm Grove Road as seen here in 1966, two years before its closure. The railway track was laid in 1917, and in 2009 all that remains is a length of track preserved in the grass beside some garages, opposite the spot where the line entered the station yard on Union Street.

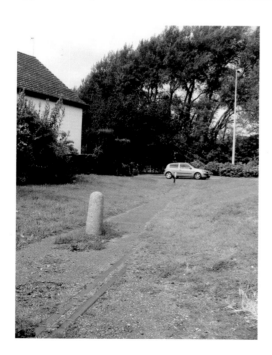

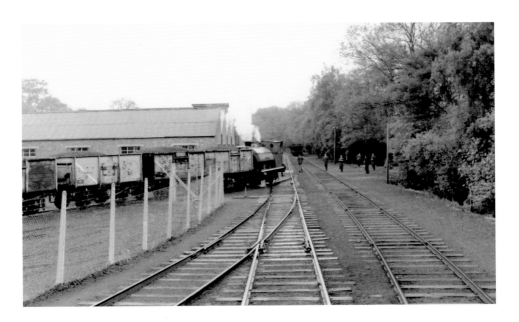

The Invincible

The principal engine on the RAE railway was the *Invincible*. In this photograph from the 1960s it can be seen beside some oil stores alongside Marrowbrook Lane, on the perimeter of the RAE. The present photograph shows Invincible Road which follows the line of the old railway and serves an industrial estate. The *Invincible* engine was retired to the Isle of Wight where it is still in service.

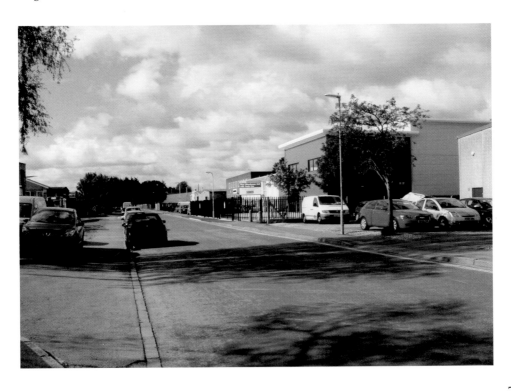

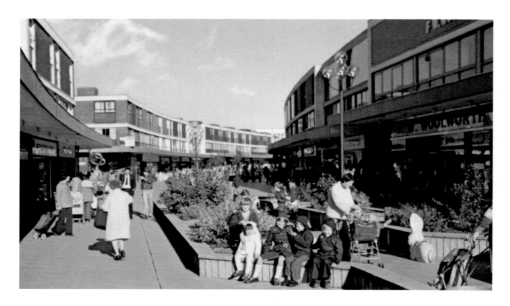

Queensmead

Two houses, named Queensmead and Kingsmead, on Victoria Road were pulled down in the late 1950s to enable a state-of-the-art shopping centre to be built on the land behind. Later on the closed-in shopping malls of Kingsmead and Princes Mead were built alongside. Now, fifty years on, many shops in Queensmead have closed and the whole area is undergoing regeneration, with the northern end being totally redeveloped to incorporate retail shops, a number of residential units and a hotel.

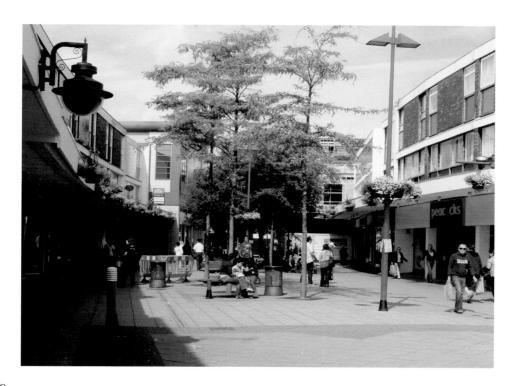

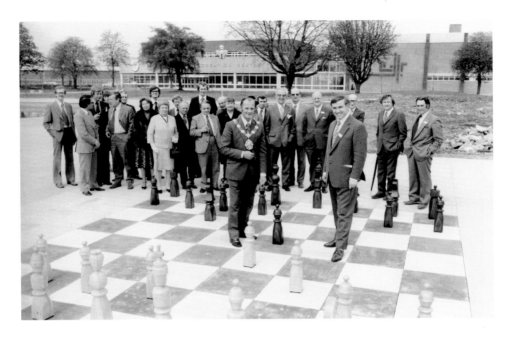

Giant Chess Board

The recreation centre was built in 1970 and a giant chess game was considered an innovative recreational activity set within the adjacent landscaping. The chess board was opened by the mayor in 1976 but was eventually paved over because of lack of use. One wall of the recreation centre has been decorated with an informative mural in mosaic, depicting various milestones in the history of Farnborough, from the Domesday Book, shown in the inset, to the advent of town twinning.

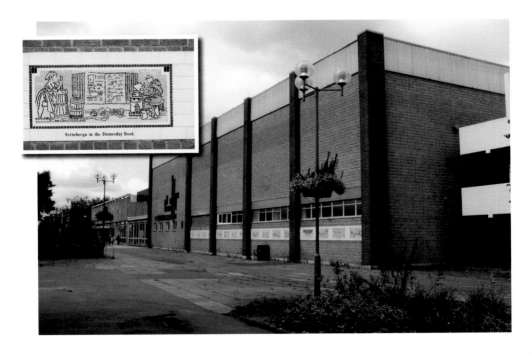

Ferneberga in the Domesday Book.

The Workhouse, Union Street

This had become a private house when this photograph was taken in 1980, just prior to demolition. Built in 1793 and closed in 1868, it was a home for the displaced poor people from the parishes of Cove, Farnborough, Yateley, Hartley Wintney and Hawley. In the former workhouse grounds behind the modern house seen in the lower photograph lies Sullivan Close, so-named because the composer Sir Arthur Sullivan is reputed to have attended a nearby school.

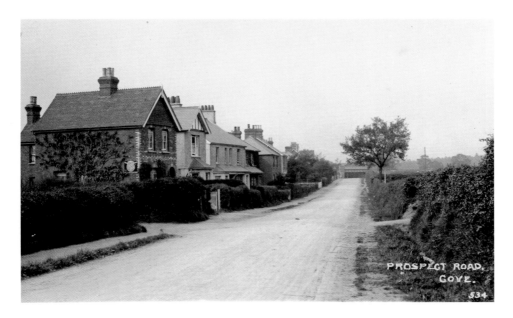

Prospect Road

There is a clear view along Prospect Road towards the railway bridge in the 1930s when it was more like a lane alongside Cove Green on the right. Frog Lane, now called Holly Road, is on the left. Today, trees and vegetation mask the view, but in the allotments opposite the bridge is a concrete pillbox, erected during the Second World War as an anti-invasion measure.

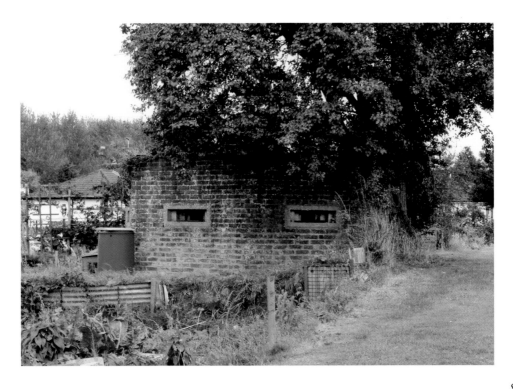

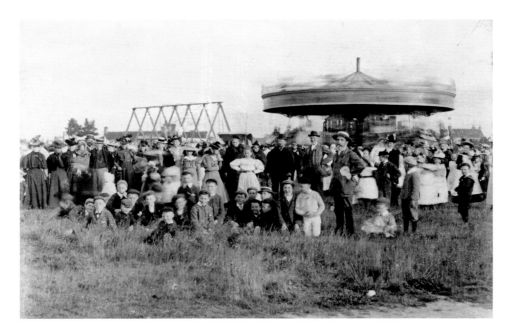

The Fair on Cove Green

The annual fair was a highlight in the school year when the children would march down from Cove School to take part in sporting activities. The treat was to enjoy the rides provided by Matthews' Funfair. In the photograph, probably taken just before the First World War, the camera has not been able to compensate for the fast moving steam gallopers. Still a popular recreational area today, it has a dedicated play area but has not seen a fair for many years.

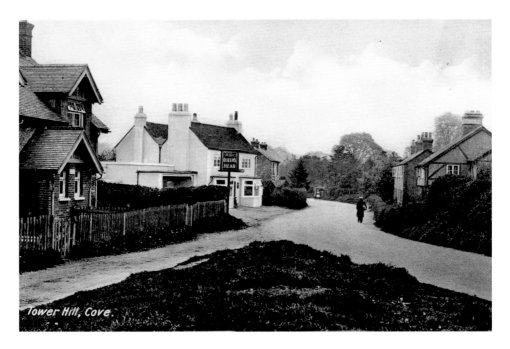

Tower Hill

Not a steep hill but on slightly higher ground to the south of Cove Road. This view northwards along Marrowbrook Lane, one of the oldest lanes in the village, has changed dramatically in recent months following the demolition of the Queens Head. An archaeological dig on the site has revealed supporting evidence of the early pottery industry known to have existed in the surrounding area. A few cottages on the right still reflect an earlier era.

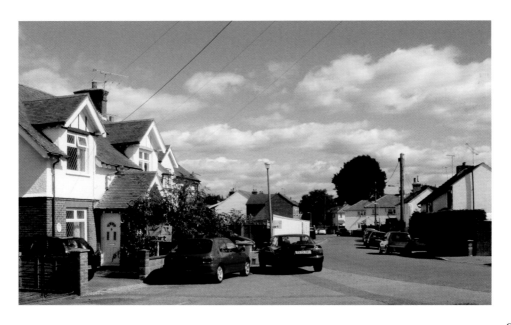

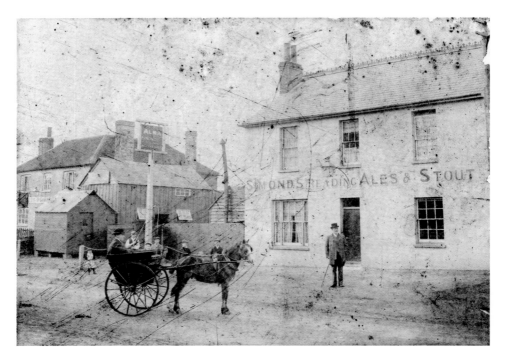

The Alma and The Anchor

This faded photograph, taken at the end of the nineteenth century, is a rare picture of a dog-cart, designed for one person to drive, outside the Alma in the centre of Cove. Next door was the Anchor, mentioned in seventeenth-century records and now renamed the Old Court House whose car park is on the site of the Alma. Despite some changes, today's view still bears considerable resemblance to some of the old picture postcards.

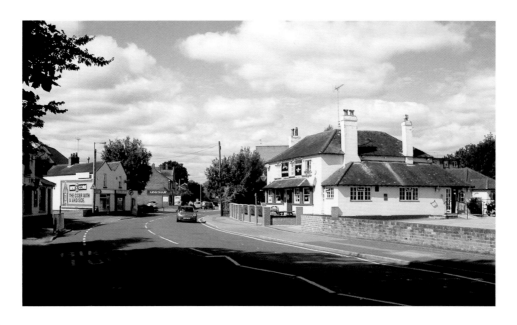

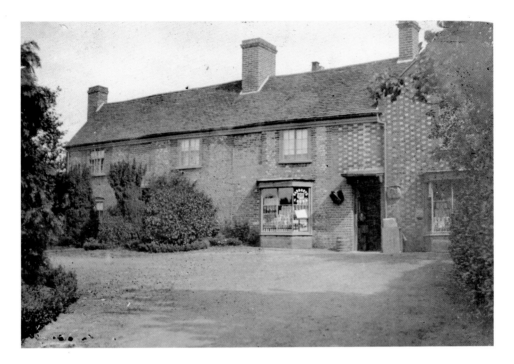

Moore's Bakery

This row of cottages, with Mr 'Tots' Moore's bakery on the right, was at the bottom of Tower Hill, just behind Instone's Garage. Like many of the old cottages in Cove, it has long since been demolished. Mr Moore moved his bakery just round the corner to Cove Street, now known as Cove Road. Tower Hill Garage has replaced Instone's, with the car sales area at the rear being on the old bakery site.

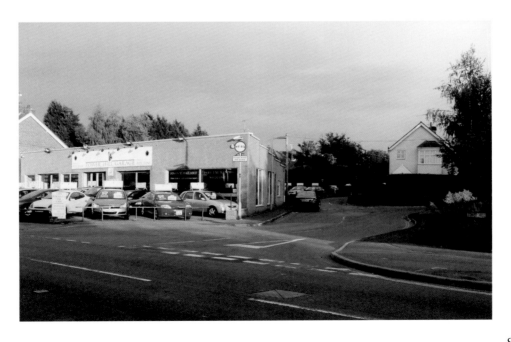

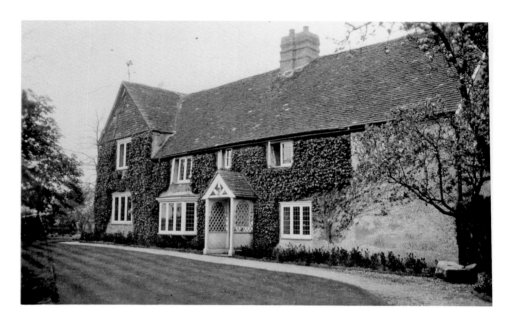

Cove Cottage

Part of this house dated back to the fourteenth century and, with numerous alterations, became one of the larger houses in Cove, as shown in this photograph believed to have been taken in the 1930s. It is understood that the house had uneven floor levels, a winding staircase and some beautiful oak panelling. Originally part of Hook Farm on the north side of Hazel Avenue, it was pulled down to make way for the houses in Cranleigh Court.

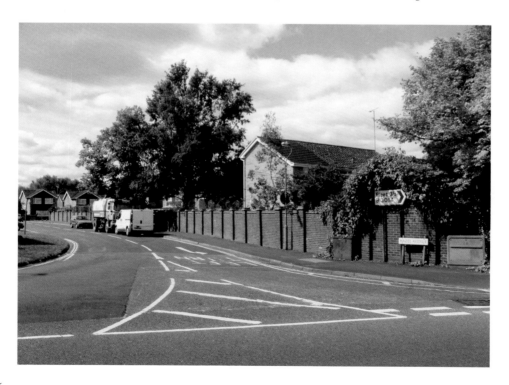

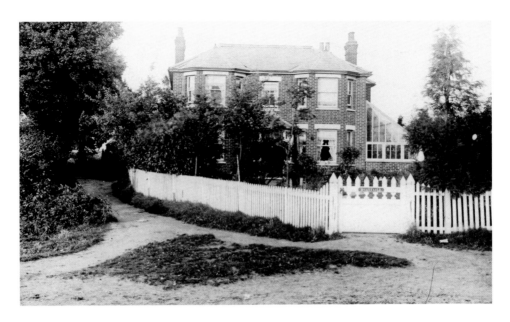

Highfield

A veterinary surgery and modern houses have replaced this imposing property on a prominent corner of Bridge Road in Cove. It was possibly given the name in connection with the original field on rising ground next to Cove Brook. The footpath to the left has now become Highfield Path which is something of an anomaly as it is really a road with houses on both sides.

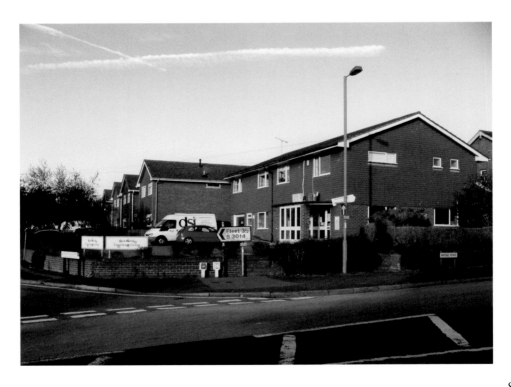

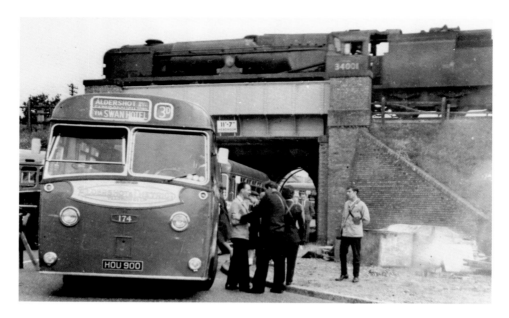

West Heath Bridge

This scene in 1962 illustrates the disruption caused when this narrow bridge was temporarily closed to road traffic. Passengers travelling by bus between West Cove and Farnborough had to get off one bus, walk through the tunnel and rejoin another bus to continue their journeys. Not long afterwards a new bridge was built to accommodate a wider road which made life for the motorist a great deal easier.

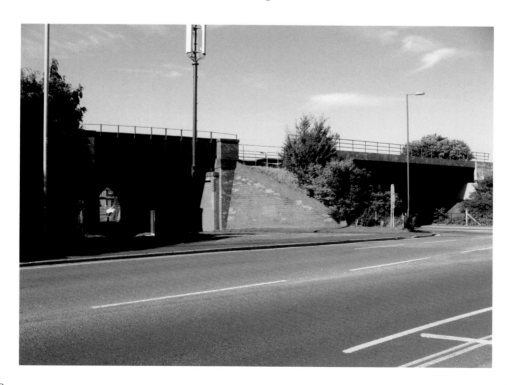

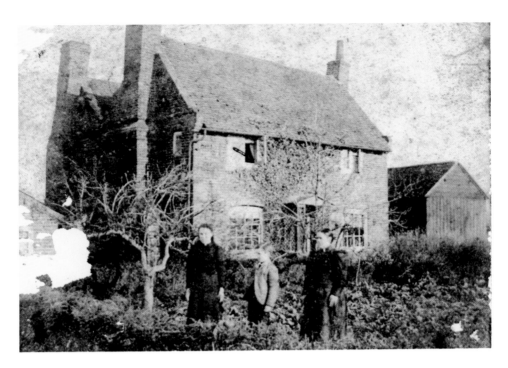

West Heath Farm

At the time of this rare and damaged photograph, *c.* 1900, the farm was owned by Mr Blunden, but it first appeared in the records in 1705. After the house was demolished in the 1960s, the farmland became the West Heath Estate. The rear entrance to the old farm was at the end of this little lane off Fernhill Road. April Cottage, on the corner, is believed to have been a pub called the Jolly Sailor.

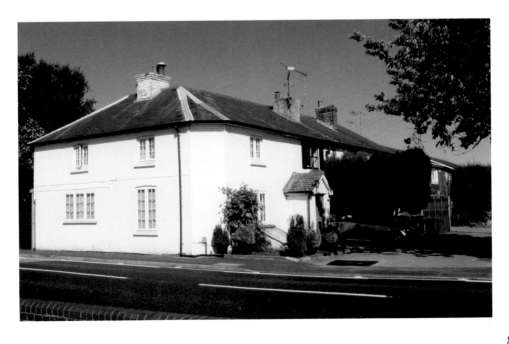

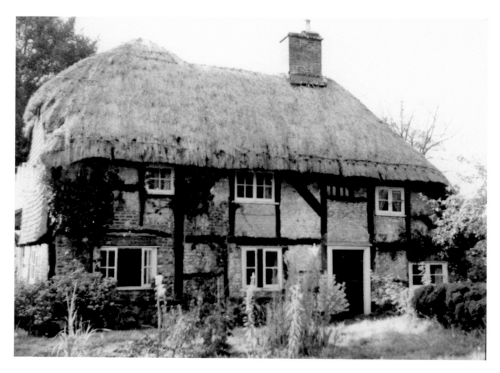

The Thatched Cottage, Prospect Road

Nowadays, this is the only thatched building in the town to survive amid the destruction of all the historic farms in the vicinity. Believed to have been built in the eighteenth century by Thomas Goddard, an extension in the 1930s doubled its size from a two bedroom cottage. In 1964 it was sold to a brewery. Additional extensions and the turning of the front garden to a car park have resulted in an attractive and well-established pub in a heavily populated residential area.

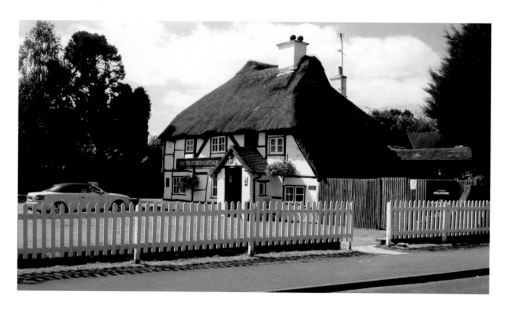

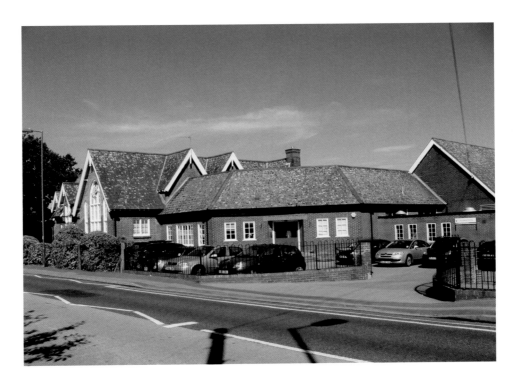

Cove Junior School

It was known as Cove School from 1880 until the senior children moved to the new Cove Secondary School in the 1930s. In the 1914 photograph, the girls are in the headmaster's garden next door, preparing for the annual school treat on Cove Green. The headmaster's house was demolished after an aircraft crashed into it in 1946, severely damaging the school. In 2009 the original part of the school is seen on the left.

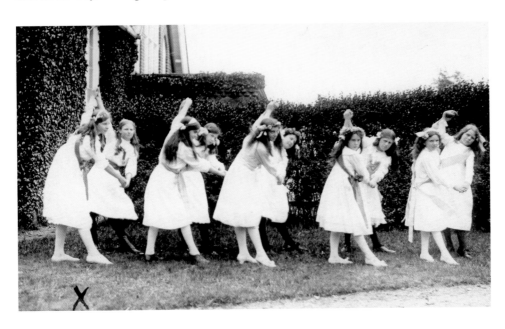

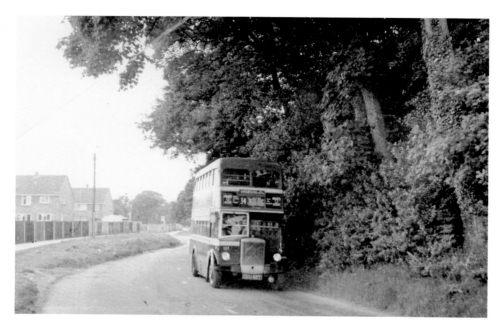

Fernhill Road, Originally Named Hawley Road

In 1962, this No. 34 bus was on a regular cross-country route from Cove to Guildford. The houses on the left are on the junction of Northcote Road and are very difficult to identify because nearly all have been extended. The thick vegetation of this once-quiet country road has now given way to a densely populated area to the right at the junction of Medway Road.

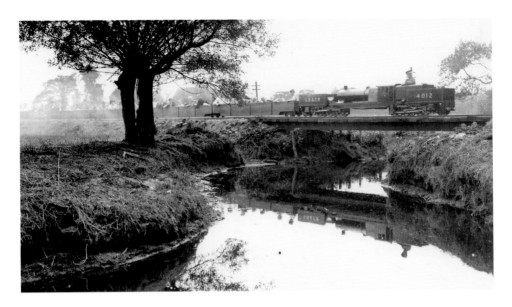

The Farnborough Miniature Railway

This is just a glimpse of happy times in 1936 when a railway enthusiast built a miniature railway and opened it up to the public. Seen here crossing the River Blackwater, heading for Cove Wood, it was constructed on land that was eventually swallowed up by junction 4 of the M3. The railway closed in 1939, the river course has been altered and the ceaseless drone of traffic has replaced the evocative sound of a steam train puffing through the fields.

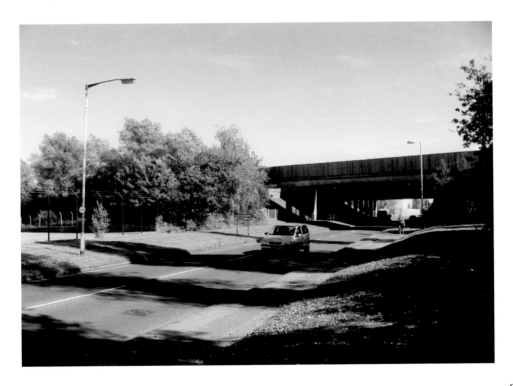

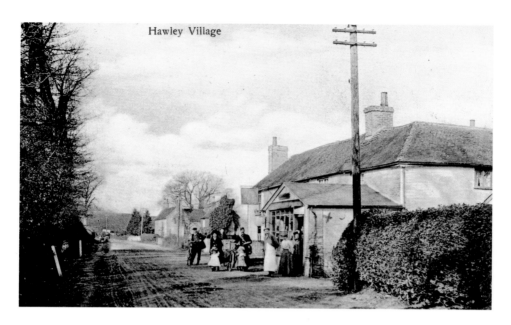

Hawley Village

New Inn, Hawley

This postcard from 1905 reflects part of another village that was incorporated within the old Farnborough Council administration. The New Inn on the right suffered several fires over the years leading to its eventual demolition. On the site today is a modern pub restaurant carrying the old name. Nearby, tucked away behind a tree, lies the only cottage remaining from the old picture.

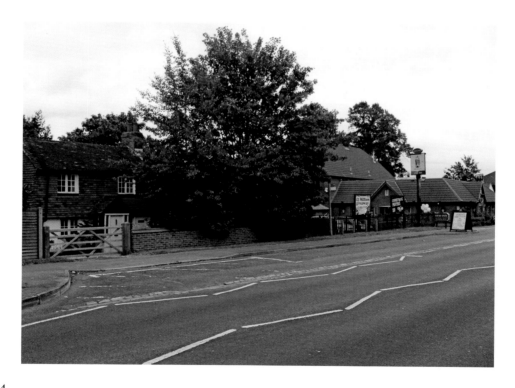

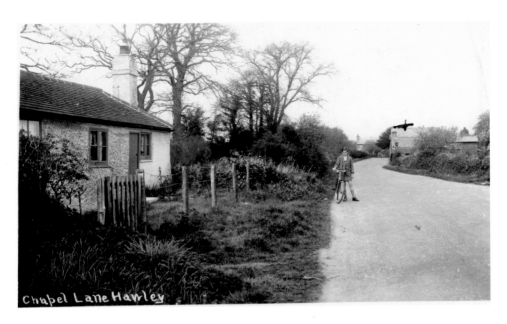

Chapel Lane, Hawley

The house marked conveniently with a cross on this postcard of the 1920s was originally the Methodist chapel after which the lane is named. One small cottage has gone, but this small cluster of old buildings with names like Ye Old Malt House and Chapel House has resisted the onslaught of the developers. They, like the first pictures in this book, bear witness to the rural origins of the town.

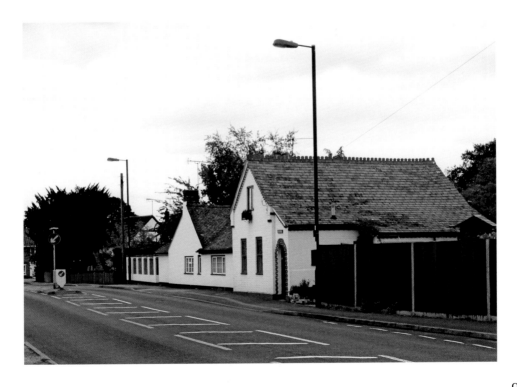

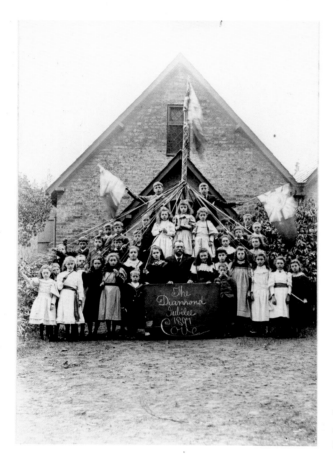

The children of Cove celebrating Queen Victoria's diamond jubilee in 1897.

Acknowledgements

The Aviator, P. Burton, Hugh Davies, Farnborough College of Technology, Farnborough International Events Ltd, Farnborough Library, FAST Museum, P. Grantham, John Grenham, Paula Hill, Don Minterne, M. Moore, Mrs A. Norman, Sister Rennie, David Spooner, TAG Aviation, J. Thripp, Hugh Winter, Mrs D. Woods, G. Woolger.

Special thanks go to Michael, my ever-supportive husband, for taking so many of the modern photographs.